D1242546

Eiteljorg
Museum

Indianapolis | visit us at **eiteljorg.org**

Eiteljorg Museum of
American Indians and Western Art
Telling Amazing Stories

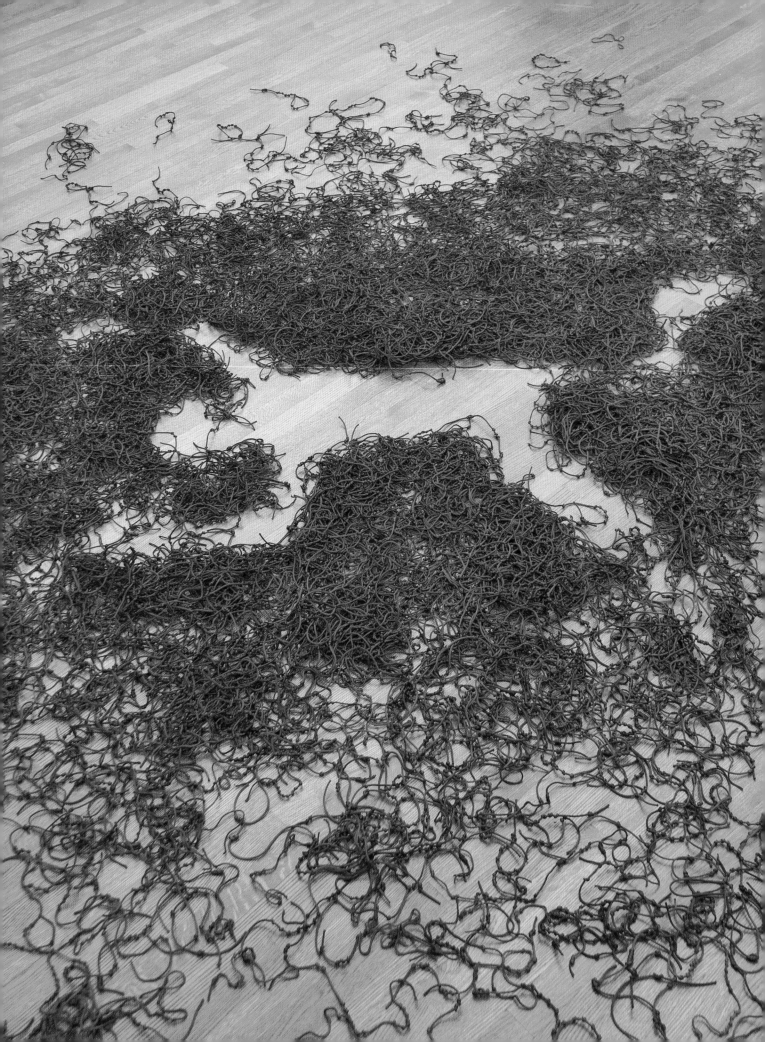

CONVERSATIONS
Eiteljorg Contemporary Art Fellowship 2015

Edited by Jennifer Complo McNutt and Ashley Holland (Cherokee Nation)

Eiteljorg Museum of American Indians and Western Art

Opposite: Luzene Hill (Eastern Band of Cherokee)
Retracing the Trace (detail), 2012
Cord, ink, pastel

Library of Congress Cataloging-in-Publication Data

Conversations (Eiteljorg Museum of American Indians and Western Art)
 Conversations : Eiteljorg Contemporary Art Fellowship 2015 / Edited by Jennifer Complo McNutt and Ashley Holland (Cherokee).
 pages cm
 Includes bibliographical references and index.
 ISBN 978-0-9961663-0-0 (paperback)
 1. Indian art--United States--21st century--Exhibitions. 2. Art, American--21st century--Exhibitions. 3. Eiteljorg Museum of American Indians and Western Art--Funds and scholarships. I. Holland, Ashley (Ashley R.), 1983- editor. II. McNutt, Jennifer Complo, editor. III. Eiteljorg Museum of American Indians and Western Art. IV. Title.
 N6538.A4C66 2015
 704.03'97007477252--dc23
 2015026900

ISBN: 978-0-9961663-0-0

Eiteljorg Museum of American Indians and Western Art, 500 W. Washington Street, Indianapolis, IN 46204, U.S.A. (317) 636-9378; http://www.eiteljorg.org

Editorial services and project management by Suzanne G. Fox,
 Red Bird Publishing, Bozeman, Montana
Graphic design by Steven Sipe, Director of Exhibition and Graphic Design,
 Eiteljorg Museum, Indianapolis, Indianapolis
Indexing by Sherry L. Smith, Bend, Oregon
Proofreading by Jena M. Gaines, Providence, Rhode Island
Unless otherwise noted, all photographs are by Hadley Fruits, Indianapolis, Indiana.

Front and back cover: Mario Martinez (Pascua Yaqui), *The Conversation* (detail), 2004
See page 18.

Special thanks to the following sponsors for their generous support of *CONVERSATIONS: Eiteljorg Contemporary Art Fellowship 2015.*

PRESENTED BY:

SPONSORED BY:

David Jacobs
David H. and Barbara M.
 Jacobs Foundation

EFROYMSON
FAMILY FUND
A CICF Fund
Inspiring philanthropy

ADDTL. SUPPORT PROVIDED BY:

Gerald and Dorit Paul

IceMiller
LEGAL COUNSEL

ARTSCOUNCIL

INDIANA ARTS
COMMISSION
MAKING THE ARTS HAPPEN

Contents

Foreword

By John Vanausdall, President and Chief Executive Officer
Eiteljorg Museum of American Indians and Western Art

This is our ninth *Eiteljorg Contemporary Art Fellowship* round! Looking at the group this year, we examine through the art issues of family, language, and violence against women. This exhibition and round makes a powerful statement; or should we say, another powerful statement. The exhibition brings Native issues into a personal perspective. It helps our audiences create understanding and empathy for Native people and develop an appreciation for Native contemporary art.

Our 2015 invited artist Mario Martinez (Pascua Yaqui) is an example of how indigenous thinking is influencing people in all walks of life. He lives and works in New York City in one of the most vibrant art centers in the world. His work is influenced by his environment, but he is equally influential with his conviction and belief in the Yaqui worldview. According to Martinez, "it's all Yaqui. That is what my work is about from the beginning into the future, Yaqui."

Da-ka-xeen (Tlingit/Nisga'a) Mehner is helping revive his Native language through song. Because using Native language was discouraged and punished during his parents' generation, Mehner has committed to helping revive and keep this aspect of his culture alive.

Luzene Hill (Eastern Band of Cherokee), Brenda Mallory (Cherokee Nation), and Holly Wilson (Delaware Tribe of Western Oklahoma/Cherokee), are all Cherokee from different bands with a shared cultural history. Each has very personal stories to contribute to the varied and misunderstood group known as Cherokee. Hill uses her devastating experience with rape as a way to overcome and give voice to this violence that is often shrouded in silence and shame. Wilson uses fairy-like figures to portray stories that combine whimsy with the deep connection she has to family. And Mallory examines abstraction and the realities of being a Cherokee raised off and far from the reservation and community.

Opposite: Da-ka-xeen Mehner (Tlingit/Nisga'a)
Language Daggers (detail), 2012
Steel

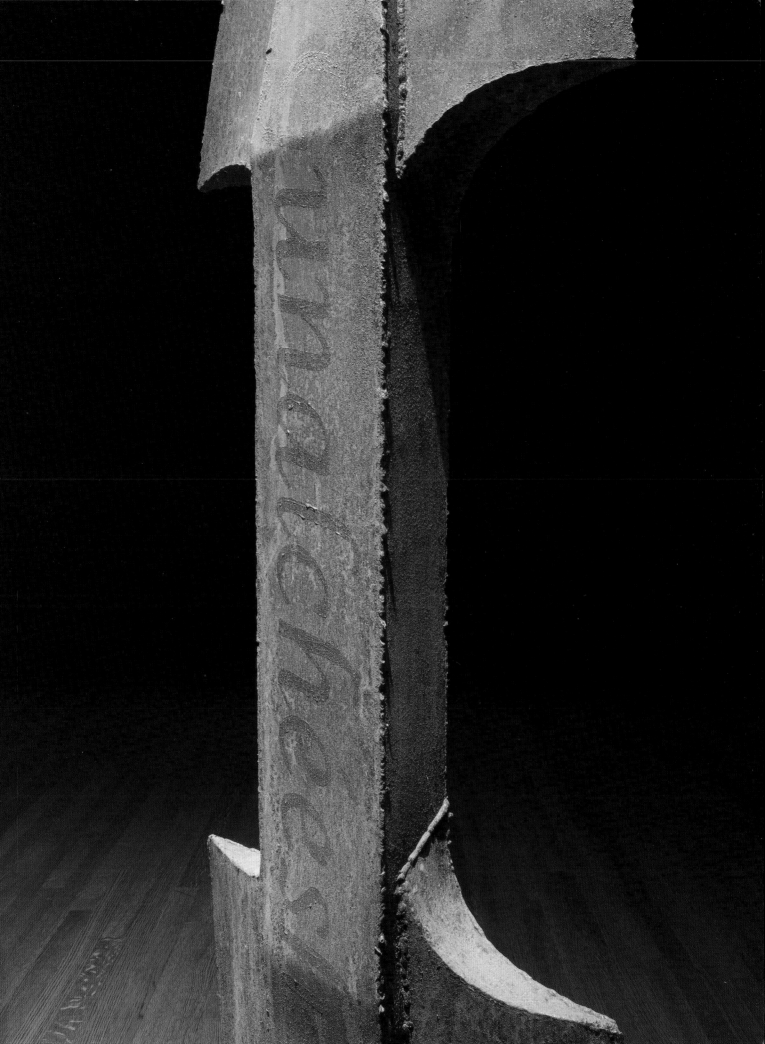

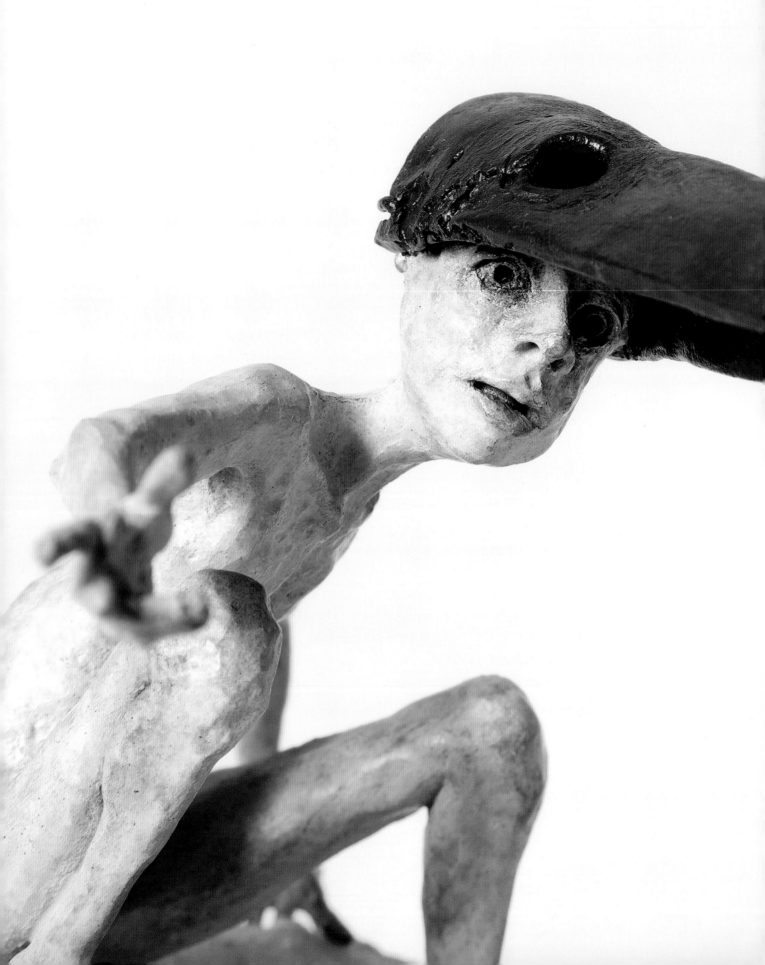

Presenting art and issues that represent Native people, no matter how challenging, creates a relationship of cooperation and collaboration between the institution, its staff, board, and constituents. Without this collaboration, our efforts would be shallow. However, the museum, artists, and scholars working together are able to create an atmosphere of mutual respect that leads to greater understanding. Reflecting on our efforts over the past twelve years, there are some obvious tenets the institution relies on for this program.

We look to the Fellowship to help audiences see Native people as living people, to bring awareness and critical understanding to issues that are important to the Native communities. The projects help engage audiences in an enlightened understanding of Native people, their history, art, and culture. Paramount is developing the contemporary Native Art collection, and we are well on our way with over 200 iconic works collected over the last nine rounds. The Eiteljorg looks forward to our next nine rounds.

The Eiteljorg Contemporary Art Fellowship program would not be possible without the generous financial support of many. From the inception of the Fellowship in 1999, Lilly Endowment has been on board with extraordinary financial commitment. The Lilly Endowment remains the primary support source for the project, with much of its gift going directly to the artists themselves. Once again this year, a major grant from David Jacobs and the David H. and Barbara M. Jacobs Foundation provides leadership-level funding. The Efroymson Fund of the Central Indiana Community Foundation also has provided major support, with additional support from Ice Miller law firm and Gerald and Dorit Paul. Equally important is the commitment of the Eiteljorg Museum staff, and I would like to thank especially Jennifer Complo McNutt, the museum's curator of contemporary art, assistant curator Ashley Holland and Vice President and Chief Curatorial Officer, James Nottage. Together, they are the exceptional leadership team who put this book and exhibition together.

Opposite: Holly Wilson (Delaware Tribe of Western Oklahoma/Cherokee)
Belonging (detail), 2014
Bronze and geode

Introduction
The Making of the "Best Collection of Native Contemporary Art in the World"

By Jennifer Complo McNutt and Ashley Holland (Cherokee Nation)

In 2014, the Eiteljorg Museum of American Indians and Western Art celebrated its twenty-fifth anniversary. Such a time calls for reflection and introspection. One of the museum's greatest accomplishments is the Eiteljorg Contemporary Art Fellowship. The story of the Fellowship is circular, renewable. It is continually changing by virtue of the art and artists' experiences it honors

The genesis of the Fellowship program is simple. With the support of the Lilly Foundation and a myriad of forward-thinking sponsors over the years, a program has been developed that has changed the field of Native contemporary art while propelling the Eiteljorg Museum onto a national platform. This visibility has created competition among museums to collect Native contemporary works, all vying for and often claiming the most, the best, and the biggest such collections.

Since its creation, the Eiteljorg Contemporary Art Fellowship has awarded fifty artists a total of over one million dollars in direct support, produced nine exhibitions with accompanying scholarly catalogues, added by purchase more than 200 works of art to the permanent collection, and promoted contemporary Native art and artists to a national audience. As a proponent of advocacy and recognition of Native contemporary art as an important form of expression, the Eiteljorg Museum packs quite a punch.

The Fellowship underscores that this young institution has made and continues to make critical contributions to the field of Native contemporary art through exhibitions and publications. Furthermore, the museum has earned the reputation of sustaining the most meticulously cultivated collection of Native contemporary art in the world. It is a collection that has raised the bar, challenged the status quo of other institutions, and succeeded. This success furthers the important contributions Native artists continue to make, that educate and celebrate indigenous ingenuity, adaptation, and resilience.

Opposite: Allan Houser (Warm Springs Chiricahua Apache, 1914-1994)
Morning Prayer (detail), 1987, cast in 1997
Museum purchase with funds provided by Joan and Mel Perelman, 1998.178 © Chiinde LLC

With a spirit of enthusiasm and anticipation, the Eiteljorg presents the 2015 Fellowship, *Conversations*, marking the ninth round of the program and the continuing tradition of Native expression. This year's fellows are Luzene Hill (Eastern Band of Cherokee), Brenda Mallory (Cherokee Nation), Da-ka-xeen Mehner (Tlingit/Nisga'a), Holly Wilson (Delaware Tribe of Western Oklahoma/Cherokee), and invited artist Mario Martinez (Pascua Yaqui).

Luzene Hill is a conceptual artist specializing in installation, sculpture, and drawing. She has exhibited throughout the southeast United States and contributed to the exhibition *Changing Hands: Art Without Reservations 3*, produced by the Museum of Arts and Design, New York, NY. Her work has evolved over the years from a two dimensional medium to performance and installation that is conceptual in nature. The theme of silence plays a part in all of her expression.

Brenda Mallory is a Portland, Oregon-based sculptor whose work can often take the form of large-scale installations. She is the recipient of numerous awards and grants such as the Oregon Arts Commission's Career Opportunity Grant and a project grant from the Regional Arts and Culture Council in Portland. Mallory's sculptures incorporate natural materials such as cotton and wax with more industrial implements such as nuts and bolts.

Da-ka-xeen Mehner is a multimedia artist who uses mediums such as sculpture, installation, photography, and film. Mehner's work demonstrates his direct relationship with his culture and his work is often conceptual in nature and engaging to the audience. Mehner was a 2014 Native Arts and Cultures Foundation Fellow in Visual Arts and he currently works as an assistant professor of Native Arts and Alaska Native Art History at the University of Alaska, Fairbanks.

Holly Wilson is a sculptor and photographer who has shown throughout the United States and extensively in Oklahoma and Texas. From 2009 to 2014, she was a member of the *Urban Indian 5*. Storytelling plays an important part in the work of Wilson and her delicately small pieces create imaginative narratives much larger than their size.

Invited artist Mario Martinez is a Brooklyn, New York-based painter who has exhibited throughout the United States. His work is found in collections such as the Smithsonian National Museum of the American Indian, Tucson Museum of Art, and The Heard Museum. Martinez incorporates ideas of place and culture into his abstract, large-scale paintings.

This round's independent selection committee consisted of 2013 Fellow Julie Buffalohead (Ponca Tribe of Oklahoma), former contemporary art curator for the National Museum of the American Indian and 1999 Fellow Truman Lowe (Ho-Chunk), and independent art curator and consultant Mindy Taylor Ross, owner of Art Strategies, LLC and founding director of the Indianapolis Art's Council's Public Art Indianapolis. The Fellowship continues to be unique and responsive to the ever-changing Native contemporary art field because of the dedication and expertise of these selectors.

During every round, artists pose different questions through every possible medium to surprise, captivate, scare, sadden, and enlighten audiences. It is their great history and deep insights that make this exhibition and catalogue so vital in documenting Native contemporary art. This profound collection serves to introduce, document, and acknowledge the important contributions of our first Americans of the twentieth and twentieth-first centuries.

The museum has purchased the following works of art.

Mario Martinez (Pascua Yaqui)
The Conversation, 2004
Acrylic and charcoal on canvas

Luzene Hill (Eastern Band of Cherokee)
Retracing the Trace, 2015
Cord, ink, pastel

Brenda Mallory (Cherokee Nation)
Undulations (Red), 2012
Waxed cloth, nuts, bolts, welded steel

Da-ka-xeen Mehner (Tlingit/Nisga'a)
Call and Respond 1 & 2, 2014
Wood, rawhide

Holly Wilson (Delaware Tribe of Western Oklahoma/Cherokee)
Belonging, 2014
Bronze, geodes

Holly Wilson (Delaware Tribe of Western Oklahoma/Cherokee)
Masked, 2014
Bronze, African mahogany

The title of this Fellowship derives from Mario Martinez's purchased work *The Conversation*. In looking at the Fellows' work, as studio visits took place and the checklist was completed, we began to realize that all the artists were having a conversation of sorts, either with themselves, their culture, the past, or in hope of the future. These conversations are an integral part of what makes contemporary Native art so important. They force the viewer to look past misconceptions and stereotypes. They ask for a new reality, a different story, a better world. The work demands to be heard and seen without apology. This is what the Eiteljorg Contemporary Art Fellowship strives to do: to give a platform to Native artists so that their voices, their important conversations, can be heard by everyone.

Opposite: Brenda Mallory (Cherokee Nation)
Undulations (Red) (detail), 2012
Waxed cloth, nuts, bolts, welded steel

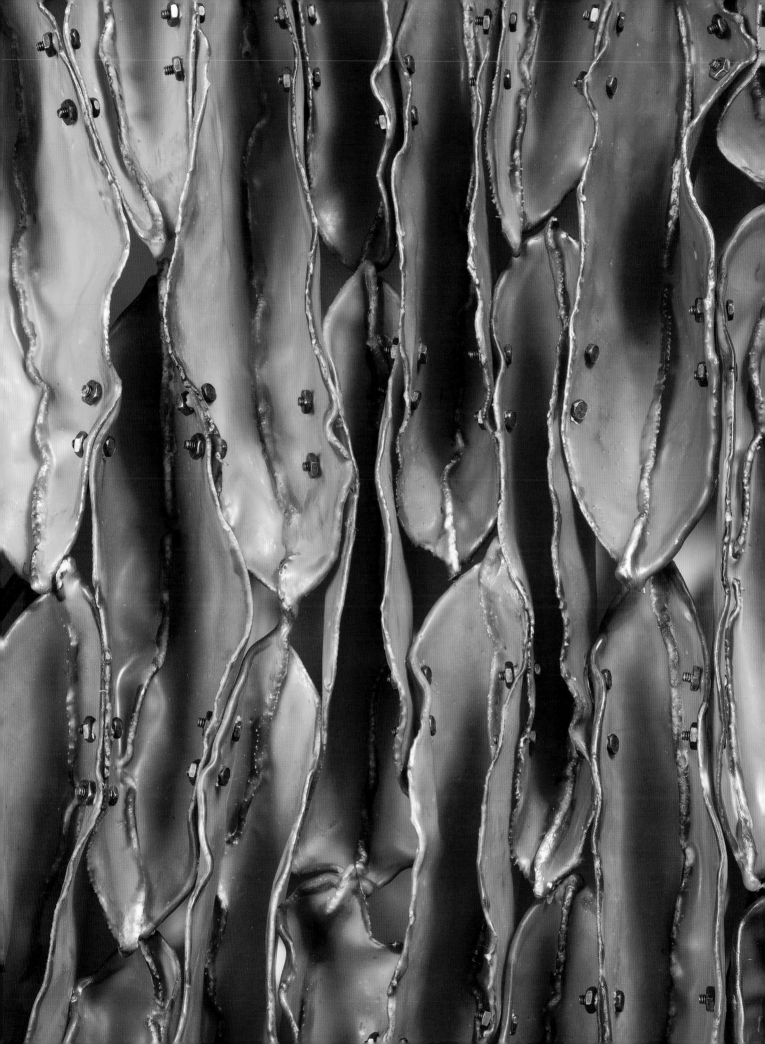

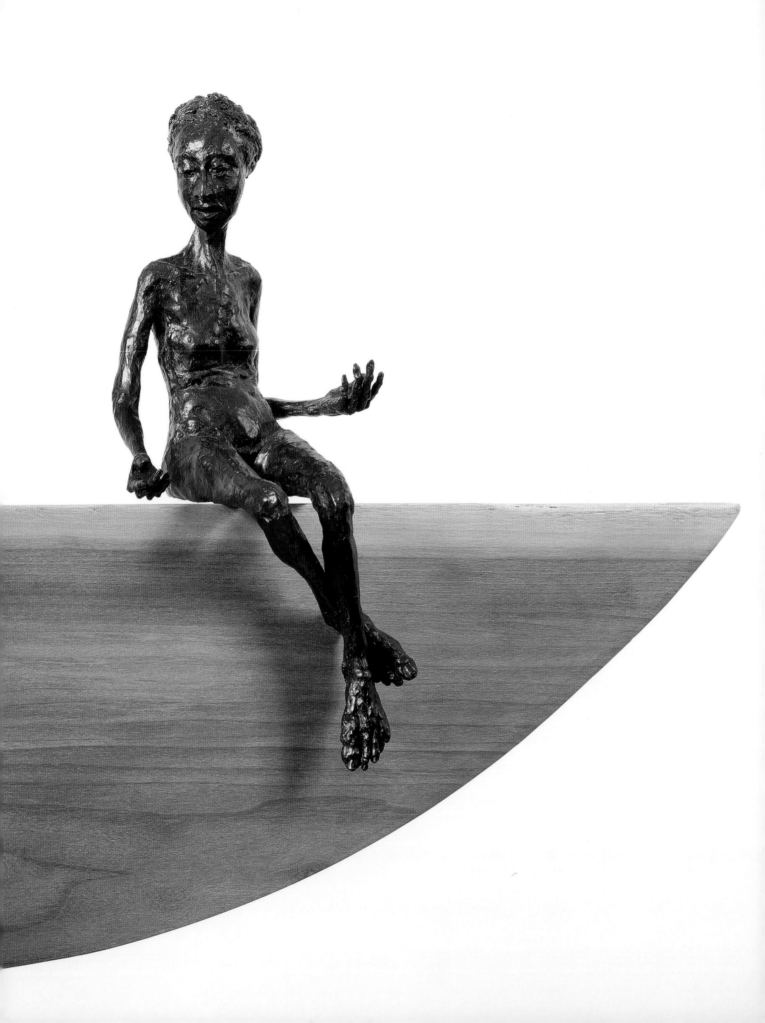

CONVERSATIONS
Eiteljorg Contemporary Art Fellowship 2015

Mario Martinez (Pasqua Yaqui)

Luzene Hill (Eastern Band of Cherokee)

Brenda Mallory (Cherokee Nation)

Da-ka-xeen Mehner (Tlingit/Nisga'a)

Holly Wilson (Delaware Tribe of Western Oklahoma/Cherokee)

Opposite: Holly Wilson (Delaware Tribe of Western Oklahoma/Cherokee)
Mother (detail), 2011
Bronze, poplar, steel

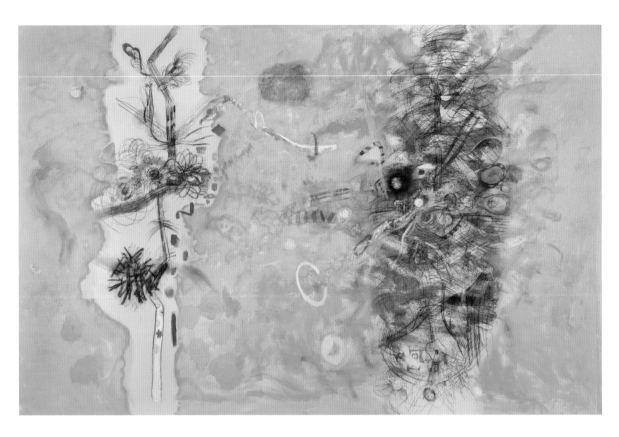

The Conversation, 2004
Acrylic, charcoal, on canvas

Mario Martinez (Pascua Yaqui):
Reigning Yaqui of New York City

By Jennifer Complo McNutt

(Detail) Photograph by Bret Sigler

Mario Martinez embraces both his culture and traditions with a love for the energy and vibrancy of the city. He has a heightened sense of self-awareness that shows him the beauty of nature all around him, whether he is on the reservation in Arizona attending Pascua Yaqui ceremonies or rushing through a sea of people on his way to his day job in New York City. His integrated approach to life and painting is that of someone who lives in the moment, who is present throughout the process that is his life and ultimately his work.

> *For me, the Sonoran Desert and Yaquiness have never left me and are ever-present even in New York City. The energy of city life influences my paintings and sometimes can even be seen in the structure of my work. The following is in the native realm and is in my own small way honoring nature: I talk to trees in New York City just like I did and still talk to the mesquite trees in Arizona.*[1]

Martinez was born in 1953 in the small Yaqui village of Penjamo, outside Scottsdale, Arizona. At the time, the population of this isolated community with very few ecomomic resources was about 350. Martinez's early experiences in this community with his family were profound, richly embued with Yaqui culture and history. This strong connection to his culture became the basis for his identity and sense of place that still inform his art work. He states, "In my time, I saw the elders who preserved the language, and knowledge of the original ways."[2]

The merger of ancient Yaqui traditons with Catholicism is a seamless combination of traditions that began in the seventeenth and eighteenth centuries, when Jesuit priests introduced Catholicism to Native peoples. The most enduring tradition of this merger is during the Lenten season when the deer dance is performed. In this ceremony, flowers are paramount because they are considered spirtiual blessings and weapons against evil. They are part of Yaqui legend and are used to describe a miracle during Christ's crucifixion, when his blood, dripping from the cross, transformed into flowers. "The ceremonies at Easter, from Lent, constitute a world-renewal ceremony. It's a ceremony in which goodness in the world overcomes evil and purifies the world and prepares it for another year,". . . "They're doing this for the whole world and not just for their community."[3]

The influence of the deer dance was depicted representationally early on in Martinez's career. His interest in the flora and fauna associated with the Sonora desert and his Yaqui culture continues to be recognizable in his current work, interpreted with varying degrees of abstraction. His loyalty to protecting the sacred and spiritual nature of ceremony and objects attached to the cultural events has been evident throughout his career as an element of mystery that lingers in the attitude of each work. Martinez carries his traditons and beliefs into each new geographical move and adventure, first from his birthplace, then to Arizona State University—Tempe School of Art, where he earned his bachelor of fine arts degree, next to the San Francisco Art Institute to complete a master of fine arts degree, and finally to his current home in New York City. No matter where he is, the Yaqui world and the power of flora and fauna always surround Martinez.

Rivaled only by his connection to his culture, Martinez's admiration for many twentieth- and twenty-first century artists has greatly influenced his work. Artists like Arshile Gorky, Mark Rothko, Wassily Kandinsky, Robert De Kooning, and Philip Guston make for a stirring group of art history combined with Yaqui culture and the personal artistic signature Martinez has developed. A discussion of Martinez's work must acknowledge its physical vitality. The majority of his work, whether on canvas or paper, is large; some works could easily be described as monumental. James Lavador (Walla Walla), painter and 2005 Eiteljorg Fellow, describes his own artistic process as a physical

recreation of the act of hiking. It is a description that comes to mind when one considers the size of Martinez's work and the athletic nature of the canvas and paint. It is as if Martinez, in sweeping gestures, collects energy and assigns it color as he applies it to the canvas. The energy consists of symbols from all aspects of Martinez's life, culture, relationships, and geography. All these and more are abstracted into his unique language in paint.

Martinez uses abstraction as a way of emphasizing the energy he gathers from the kinetic world. In the monumental work *Inside-Outside*, he has weighted the canvas like a traditional landscape; the top of the canvas feels open and airy, implying a great amount of space, while the bottom half is denser and darker. The pink, lightly modeled top or "sky" is reminiscent of Philip Guston's pinks, while two small white breaks or bursts in the surface offer a brilliant white that could be interpreted as a momentary light of understanding or a blinding light that keeps the viewer from fully understanding the philosophy of the color and mark. Martinez, in a way that may express his loyalty to the mystery of his culture, often creates what looks like a story, but in its abstraction, it is not totally accessible to the viewer, too obscure for complete understanding but still intriguing. The bottom of the painting is much closer to the viewer, disallowing entrance with a grid-like structure of black lines that are occasionally overcome by the energy and color that breaks through with more chaos. It may be a reference to the under- or other world, or simply a more complicated part of one world. The title *Inside-Outside* has many implications: Is it inward peace and outward struggle or vice versa? The differences in the two parts of the painting are made more dramatic in comparison to one another. In all, the painting presents the viewer with thoughtful ways to enter through cultural information that is slightly obscured. Most likely all and more of the homage to modernist painting traditions or personal journey are pieces of this painting.

The Conversation is another monumental painting. Similarly to *Inside-Outside*, it has two distinct sides or zones, one with more activity than the other. The application of the paint emphasizes a swirling whirlwind of texture, perhaps a conversation between the two sides. The composition is similar to an earlier work, *Mysterious Manifestations* (1999), which is vertical with a slender cylindrical form in the middle that slowly whirls, golden and bright,

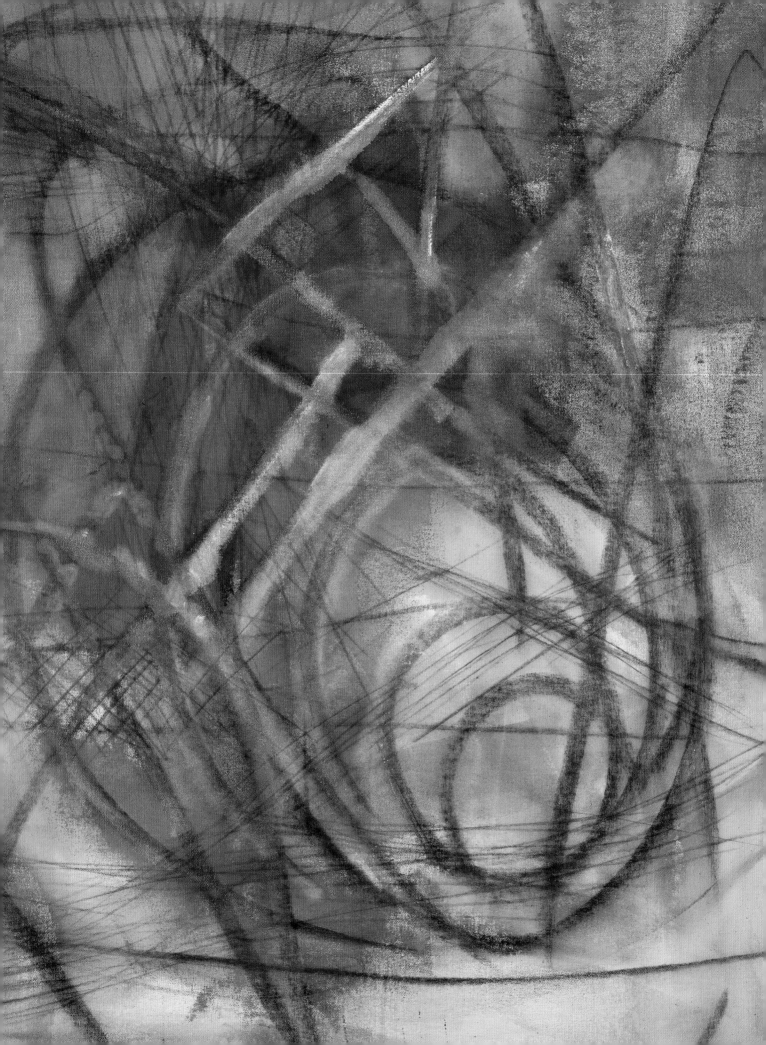

with intersecting flowers sailing through and blooming before the viewer. *The Conversation* borrows from this composition with a light-colored cylindrical form on the left that seems like a cutout space with flowers and vertical forms that also intersect and bloom inside. This is countered by a whirling dark form on the right with flowers. The figure is formed around a strong vertical that is intersected by color and lines that appear to be moving. The figure on the right is full of information, while the figure on the left is more monochromatic. Interestingly, this monochromatic painting approach or aspect comes up throughout Martinez's work. Occasionally whole paintings are dedicated to one color. It is an interesting contrast to his multi-color work. Perhaps it is a study or homage to particular artists' palettes or a distillation of shapes and energy. Martinez gives this interpretation of the work.

> *It is the Yaqui creation story or a re-creation story of what changes would come with the integrating of Catholicism into the culture. There would be new technology, new animals and a new religion.*[4]

Martinez describes the figure on the left as the talking tree that will tell the Yaqui people what the future holds. The shape or figure on the right is the universe sharing the information with the talking tree. Clearly the shape on the right is filling the left side in with much-needed information. The seemingly opposing colors, white and black, and the action of each shape, sparing or packed, may also be interpreted as a highly developed sense of and fight against evil or a heated conversation. Both forms float on a yellow/ golden background that does not indicate top or bottom. The space is ambiguous, not grounded in landscape references like *Inside-Outside*.

Finally, when one looks at his work and envisions Martinez's influences, it is interesting to imagine him spending time at the Museum of Modern Art and looking at a Mark Rothko painting such as *Slow Swirl by the Edge of Sea* (1944), a similar composition with two vertical figures on a light yellow greenish background. Abstracted and vertical, they are standing on the ground, and the energy between them, although not the same as in Martinez's work, is intriguing.

Opposite: *Inside-Outside* (detail), 2004
Acrylic, charcoal, on canvas

Martinez's move to New York was fueled in part by his ambition for and desire to be in the heart of the art world, where influences and creativity are everywhere. This move surely put him in proximity to many important abstract paintings that he has studied as both technical and emotional subjects. His discussions of abstraction often reference the abstract painter's greater ability to touch the mysterious parts of life not easily described in practical or representational language. He embraces the ideas of abstract artists living and working in the moment. Abstract expressionists are able to capture the feeling of living and creating more authentically.

> *My work has always been about life that is full of pain, suffering, and great joy, but there has always been a second half, and that is itself—the creative process of recording life in the moment, no matter how joyous or how painful, produces and aesthetic transformation.*[5]

It's Probably Magic, another monumental work, lets the viewer see Martinez's process. His vision and his beliefs are suspended in a faith and confidence about those things that are real but cannot really be known—a reference, perhaps, to the practice of traditional cultural beliefs and elements and the importance of keeping that private, and also a nod to the mysteries of life we may never understand. In his essay about Native contemporary painting, scholar Bill Anthes refers to the conundrum of the knowing and naming and the responsibility not to reveal what exists in Native culture and traditions.

> *Native arts function and signify within a complex cultural context. The aesthetic aspect of material and visual cultural products is inseparable from spirituality, connection to place, community, identity, and history. When aesthetic objects and representational practices have become estranged from this context—in the context of colonial expropriation or market exchange—these items sometimes circulate promiscuously, revealing sensitive information, secularizing sacred practices, and serving as an aid to the objectification, eroticization, and monetization of Native cultures.*[6]

It's Probably Magic is cataclysmic in the placing of elements that are emotional or spiritual within traditional artistic technique and/or compositional standards. The sense of larger-than-life power rolls like incoming weather

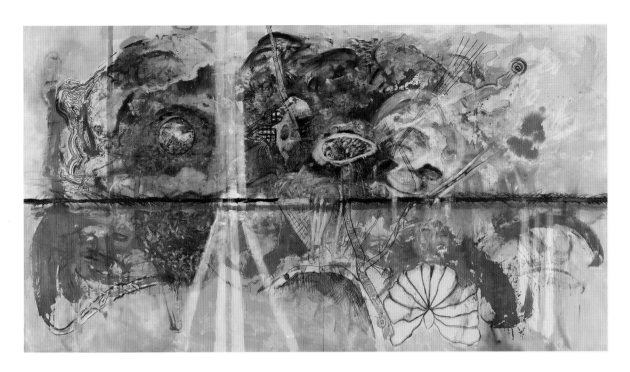

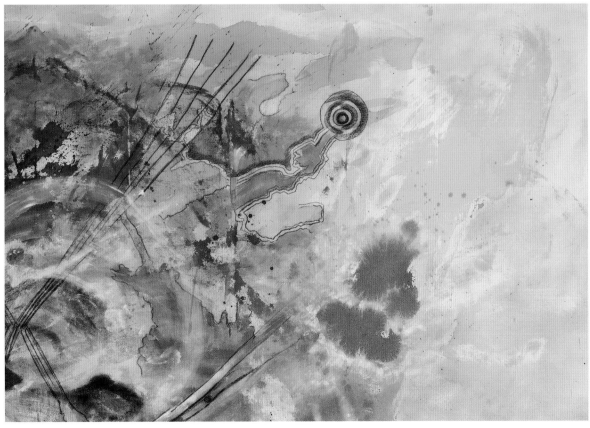

Above: *It's Probably Magic*, 2004
Acrylic, charcoal on canvas

Below: *It's Probably Magic* (detail), 2004

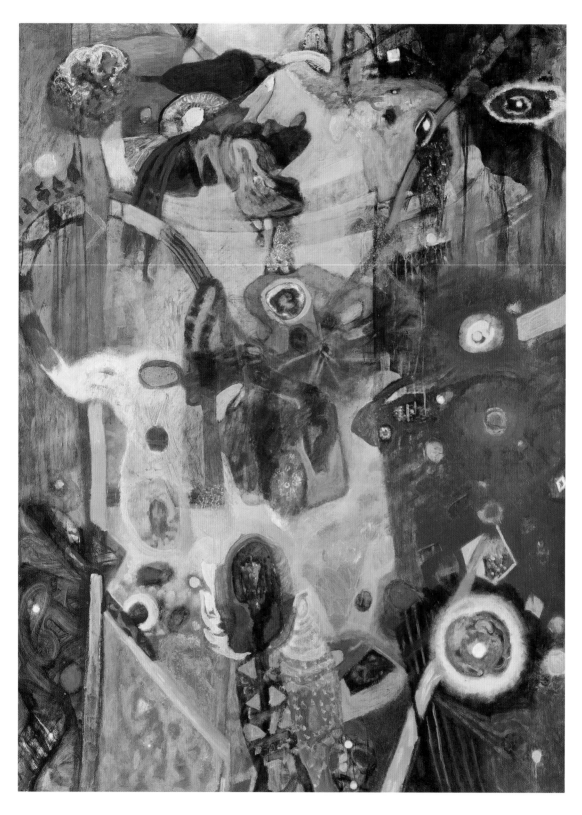

Unveiled Universe, 2005
Acrylic on paper

through the painting, unstoppable. In clear view are the flowers and plants so important to the Yaqui's sense of symbolism and defense against evil. The composition is perhaps a reference to landscape or possibly a body of water, with the red and black lines referring to the horizon. The crisper, heavier, and more distinct forms are reflected in the top half of the painting, while the forms toward the bottom lose some distinction but are still formidable. One of the contradictions of the composition is that the heavier elements of the top are being held up by the bottom forms that are strong but lighter in the weight of the paint and definition of the form. This creates visual excitement, or magic, within the canvas because it defies gravity. The vertical white lines break through both spaces, dividing to create left and right quadrants in the painting, but the strength of the two halves/reflections beguiles any distractions.

In 2005, after his successful installation and exhibition of a mid-career retrospective at the National Museum of American Indian, Smithsonian Institution, New York, as a part of the *New Tribe New York* series, Martinez created *Unveiled Universe*. The lighter palette gives way to a more robust color scheme, and the composition becomes much more architectural in structure. The vast expanses sometimes realized in Martinez's earlier pieces are compressed into the center of this composition. There is a deeper space present, but it exists within the confines of the architecture of the vertical sides. New York makes its presence known in this work. Deep concentrated areas of color, brilliant purples and rich crimson red layered with a familiar transparent gold, fall into each other with tell-tale organisms or flowers all around. In many ways, this body of work harkens back to work Martinez did in Arizona. Always energetic and somewhat enigmatic, Martinez brings together many of the color and form elements of his past and present work.

Maintaining the energy needed to create such electrifying work is phenomenal. If Martinez ever feared the exhaustion of being an artist living in New York City, maintaining a day-to-day struggle to be recognized, to continue working, and to document that work, his Yaqui nature and tenacity created a reward and a way to replenish him. The rewards or awards are from two of his favorite artists, Joan Mitchell and Robert Rauschenberg. They made their way into Martinez's studio through their legacies: the Joan Mitchell Foundation and the Robert Rauschenberg Trust. The impact these experiences has and will have on his work is still to be realized.

The Joan Mitchell Foundation CALL (Creating a Living Legacy) Artist Award 2013/2014 threw new supernatural artistic dust on my artist career. It said to me that the creative act is always worth doing come what may and that artists are lucky to be able to connect to self and consciousness (the zone) through their creative act.

Amongst other things the Joan Mitchell CALL Award organizes and saves one's work in a database for posterity. It is a great research tool. I'm so proud they felt my work was worth documenting amongst the millions of artist in the United States. My life's work has joined a special category. It's like your work can't fall through the cracks now. But also, it's so great to receive it from the foundation of one of my favorite artists of all time.[7]

The CALL award created for Martinez a strong structure and a confirmation of his life's work. Asked how the experience changed his perception of himself and his work, he stated,

The biggest change is that for me, the Joan Mitchell Foundation CALL award began the process of me being more confident in myself and my art. Now I truly believe it's a new age and that something as special and powerful as Yaqui Indian cultural concepts should be used by me (and always have been) in my abstract vision. From my point of view, native peoples of this hemisphere are extremely important because our DNA is tied to this land like no other's. We are special.[8]

Soon after the CALL award, Martinez was rewarded with an eight-week Robert Rauschenberg Residency in Captiva, Florida. That residency yielded a new body of work and further confirmed his confidence in the Yaqui worldview and how perfectly it combines with the modernist mind of abstraction.

In the monochromatic work *Blue and White*, Martinez uses broad strokes and a slower pace than in some of the other Captiva works. It is easy to imagine Martinez using a thick, wet brush heavy with watery blue paint to smoothly cover the paper. He uses his signature serpentine shapes that in this context seem similar to the irregular winding growth of the palm trees on the island. In the center are two horizontal cone shapes, one with

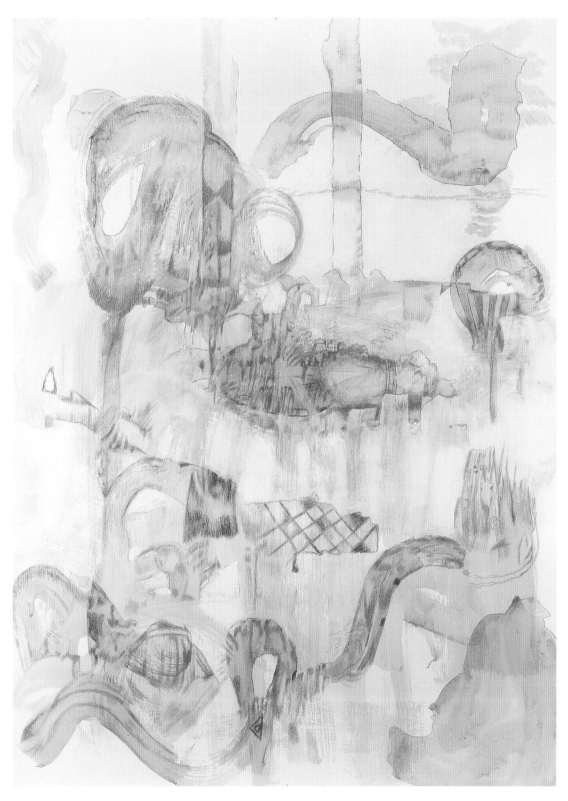

Blue and White, 2015
Acrylic, prismcolor on paper

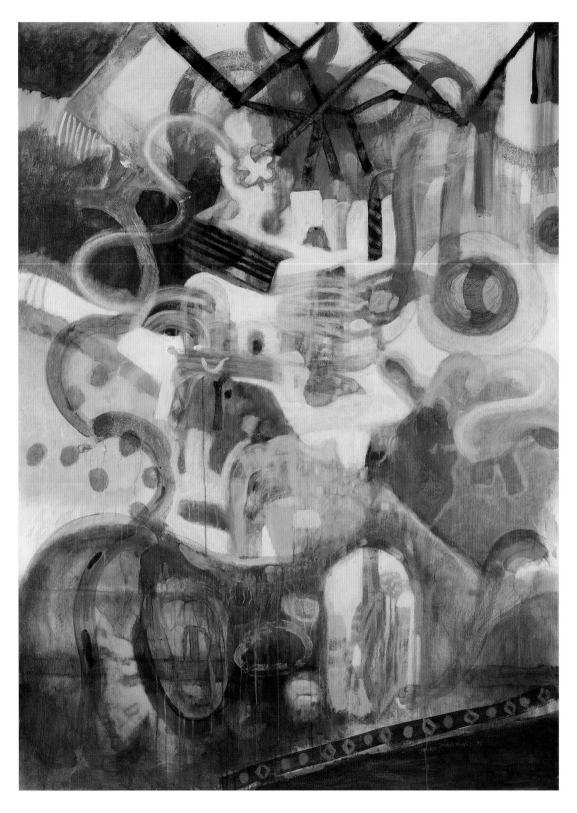

First Captiva Dream State, 2015
Acrylic, prismcolor on paper

distinct hatch marks in a pineapple pattern and all amid a fluid and brilliant translucent blue, reminiscent of the Captiva water and sky.

Counter to this monochromatic work is *First Captiva Dream State*. This painting features a layering to the brilliant blue and turquoise, red and yellow. A familiar serpent with diamond pattern appears in the lower right, and there is an edge not unlike the shoreline Martinez captures in the many photographs he took while on the island. A flower form is floating in red, and a whirling bird-like form dives into the top half of the composition. Again, there is a transparency to the way Martinez uses the paint, and there is a deep feeling of space in the bottom circular forms that provides a way in and through the painting.

In *Arizona Desert Dream (for Gorky)*, Martinez is again referring to a dream state, connecting to his abstract expressionist and surrealist state of mind. Perhaps he uses a kind of automatic painting and drawing to create the blooming figure in the center with more minutely attended-to biomorphic forms surrounding the black blossom. Surely his work and experiences on the island reside in the color, energy, and confidence gained by this experience.

> *My Robert Rauschenberg Foundation Residency in Captiva, Florida in Jan/Feb 2015 had me floating four feet in the air. It showed me another side of what an artist's life can be. It showed me that artists deserve and can receive great recognition for their creative output. [Rauschenberg's] acreage on that island was magical. While there I sensed that his was the best artist's life that one could hope to experience. I felt his generosity and love of people and other artists. To say it another way, he was there and I was privileged to cross paths with him in his artistic domain.*
>
> *I'm blessed that both Joan and Robert and other artists like them have my artistic back. I feel and know that I'm privileged to be part of their artistic legacy. I thank my lucky stars!*[9]

Martinez attributes all he has created, continues to create, and will create to "Yaquiness." Its power is so strong and so important that it has permeated each painting and drawing that he has created over thirty years, and it will continue to do so. Painting is not the popular sport of the day.

Mixed media, installations, performances, and all media that move are the fashion in the contemporary art world. Martinez is not deterred by fashion or any other obstacles. His every painting and effort reinforce his faith in his Yaqui beliefs and view of the environment, his world, work, and experiences. He thrives on his own energy. For those of us who believe in mystery and magic and painting, there is some comfort in knowing there is a Yaqui artist reigning in New York City, creating flowers with the power to fight evil, participating in a ceremony each year to save the world, keeping abstraction and painting alive.

[1] Mario Martinez, "Artist's Statement," June 15, 2015.

[2] Gerald McMaster, ed., *New Tribe New York; the urban vision quest* (Washington, DC: National Museum of the American Indian, 2005), 24.

[3] Kimberly Matas, "Yaqui Ceremonies Celebrate World Renewal," Arizona Daily Star, April 2, 2010, http://tucson.com/news/local/yaqui-ceremonies-celebrate-world-renewal/article_fca2020d-f01f-5df8-a835-8ea198d975ad.html.

[4] Mario Martinez, personal communication to author, May 12, 2015.

[5] *New Tribe New York,* 28.

[6] Bill Anthes, "Painting, Drawing, and Printmaking," ed. Veronica Passalacqua and Kate Morris, *Native Art Now* (Indianapolis, IN: Eiteljorg Museum of American Indians and Western Art, publication forthcoming), 3.

[7] Mario Martinez, personal commuication to author, April 1, 2015.

[8] Mario Marinez, personal communication to Shervone Neckles, Joan Mitchell Foundation, Creating a Living Legacy, project end report, April 9, 2015

[9] Mario Martinez, personal communication to author, April 1, 2015.

Above: *Floating*, 2004
Acrylic, charcoal, on canvas

Below: *Inside-Outside*, 2004
Acrylic, charcoal, on canvas

Brushstroke Flower RRR, 2015
Acrylic, prismcolor on paper

Arizona Desert Dream (for Gorky), 2015
Acrylic, prismcolor on canvas

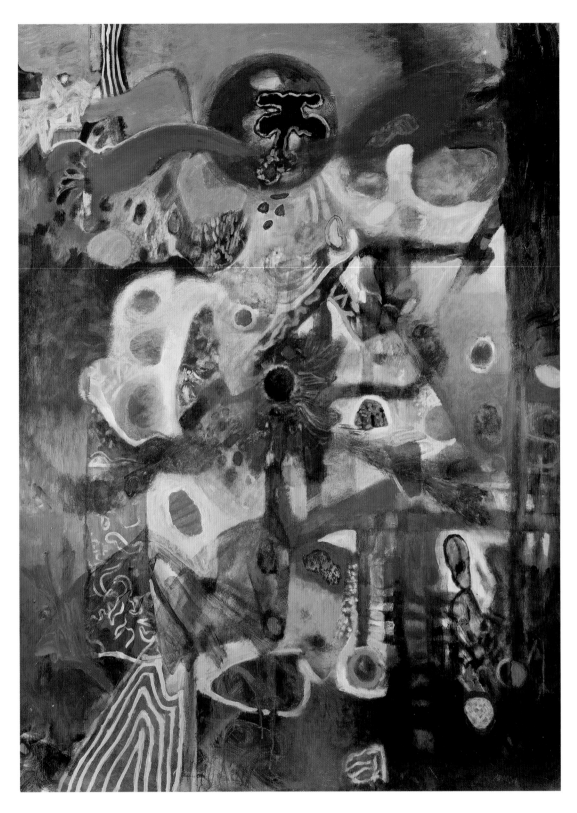

Ancestral Realms II, 2008
Acrylic on paper

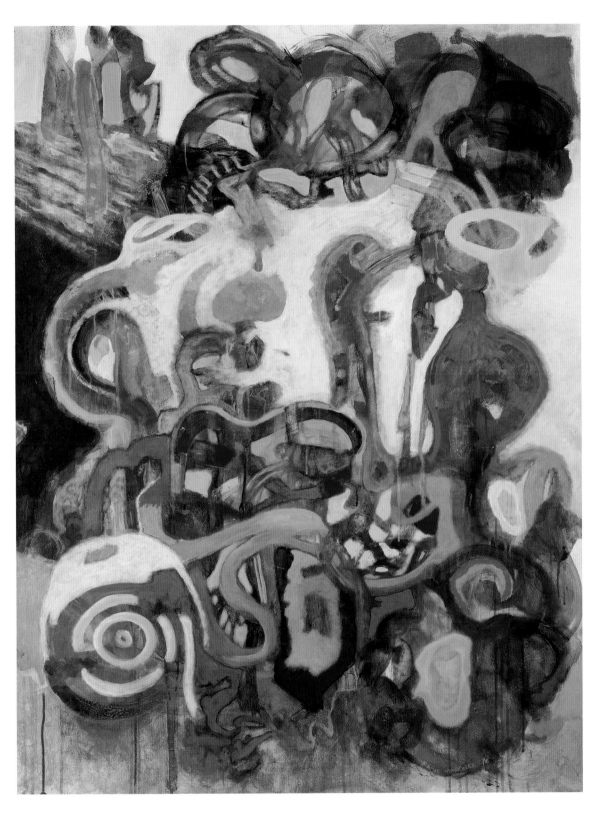

Superior Mindscape (for RR), 2015
Acrylic on paper

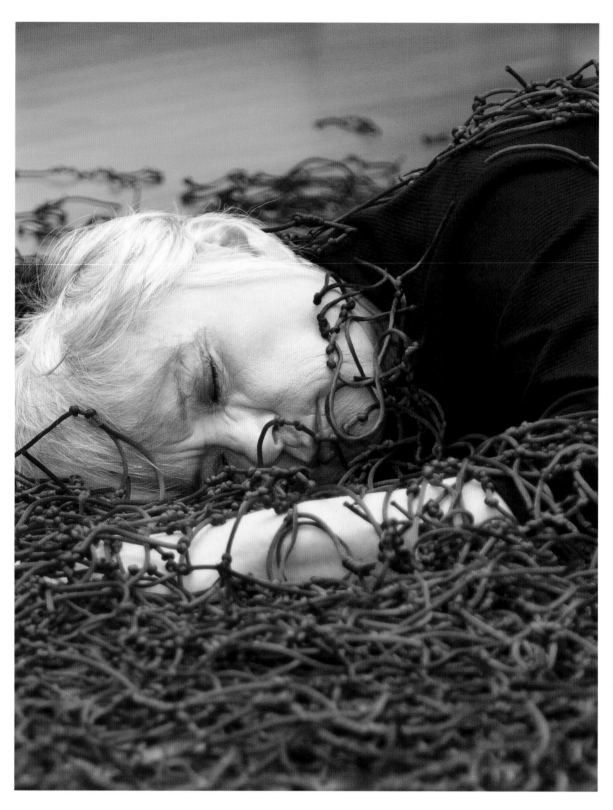

Retracing the Trace (detail), 2012
Cord, ink, pastel

Luzene Hill (Eastern Band of Cherokee):
Free Falling Up
By Martin DeWitt

Here through art I shall live forever. . .
A singer, from my heart I strew my songs
I carve a great stone, I paint thick wood
My song is in them . . .
I shall leave my song-image on earth

Toltecayootl a ycaya ninemiz ye nicã ayyo.
Ac ya nechcuiliz ac ye nohuan oyaz onicas a anniihcuihuana ayayyan
cuica-nitl y yehetl y noxochiuh nõcuicayhuitequi on teixpã ayyo.
Hueyn tetl nictequin Tomahuac quahuitl nic ycuiloa yã cuicatl ytech
aya oncan no mitoz in quemanõ in can niyaz nocuicamachio
nicyacauhtiaz in tlpc.
> —Nahuatl poem (circa 1570)

If you're not willing to risk anything, you risk even more….
> —Erica Jong

That was a touchstone for me—pushing me to take risks with my work
and eventually with my life. I have always felt that if I could only live
my life the way I make art . . . taking risks, not being afraid of "what
people think, worried about what would happen," that my life would
be stellar. I got comfortable taking risks with my work, and over the years
have gradually taken bigger and bigger risks with my life—in order to
make art. After the initial terror—life decisions, as well as art decisions—I
find the rewards overcome the terror.

VULNERABILITY.

I worked through the issues of feminine vulnerability—from being attacked, but also from a societal standpoint.—Luzene Hill

Luzene Hill is a conceptual artist who continues to examine what she says is "a vulnerable human experience" through drawings, sculpture, installations, performance, and mixed media book forms. Her ephemeral time-based, process-driven installations reflect a distinctive view of the fragility of human existence. Hill rearticulates a difficult conversation while seeking and self-acknowledging her solitary struggle amid a compound lineage of risk-takers. Assuredly, Hill aligns herself with transformative female artists from divergent nationalities who use performance and their unique cultural perspectives to express their passionate and often universal messages. Marina Abramovic (Serbian), a performance artist based in New York; Shan Goshorn (Eastern Band Cherokee), a contemporary basket maker and 2013 Eiteljorg Fellow; and Ana Mendieta (Cuban-American, 1948 – 1985), a sculptor, painter, performance and video artist, are only a few of the devoted, compassionate women with whom Hill feels an affinity.[1]

Add the monumental figures Malalah Yusafzay (Pashto-Pakistan), Rigoberta Menchú (Ki'iche'-Guatemalan), and others who continue the struggle for trans-global human rights. Hill joins these resolute standard bearers whose communal voices denounce dramatic social injustice, gender- and culture-driven disparities, and foremost, rampant violence against women. From an experiential intercultural perspective, they together have exposed the tragic breach of human rights, thus transforming the language and expanding the dialogue of contemporary fine art in all its expressive form and content and its perpetual role to implement change.

During this past decade, Hill has made a formidable journey of seeking self in her Cherokee and non-Native heritage. She has mapped a path synonymous with pilgrimage, a highly personal and artistic trek. Intent on marking time, Hill identifies and exposes violence against women via a broad cross-cultural perspective amid an extraordinary challenge that confronts

personal trauma and systemic criminal abuse. She confronts her own experience first and continues to be informed by an abundance of Native and non-Native resources that influence her creative expression. Hill states:

> *Among contemporary artists who have employed similar methodologies, or addressed similar issues, Ana Mendieta's earth-body prints, Ann Hamilton's and Wolfgang Laib's use of non-art materials and ritual in installations, along with Suzanne Lacy's use of art for social activism were most relevant to this work. Marina Abramovic influenced me to explore performance, in order to change the dynamic of the materials and the spatial energy.*[2]

The artist's Cherokee heritage is core. The heritage is vital for Hill's contextual exploration made manifest in her multi-layered creative expression, art forms directly referenced and often realized metaphorically in a broad Native American and cross-cultural experience. Hill adds to the conversation.

> *Vulnerability is a recurring theme in my work. Transformations, both physical and psychological, interest me. The process of change— voluntary or imposed, subtle or wrenching—is, paradoxically, a constant in life. I explore this fluid experience through media that are tentative, fleeting, easily altered/destroyed. The materials I often employ—paper, ink, charcoal, beeswax—are fragile and capricious, qualities that define my view of life.*

Hill, a member of the Eastern Band of Cherokee Indians (Qualla Boundary/Cherokee, North Carolina) lives and works in Atlanta. "I was born in Atlanta, my father was Cherokee—my mother (white) was from Atlanta. We visited my Cherokee grandmother and grandfather for summer vacations mostly." Metro Atlanta is three hours north and a world away via US 441 through the Chattahooche-Oconee National Forest by Gainesville…then Franklin…through the Smoky Mountains and into the Qualla Boundary. The distance is charted in time and exemplified by an outlying yet poignant reference to Hill's *Retracing the Trace* installation, in which she uses the Incan *khipu* cord system and sequential knotting to communicate and metaphorically map her own journey.

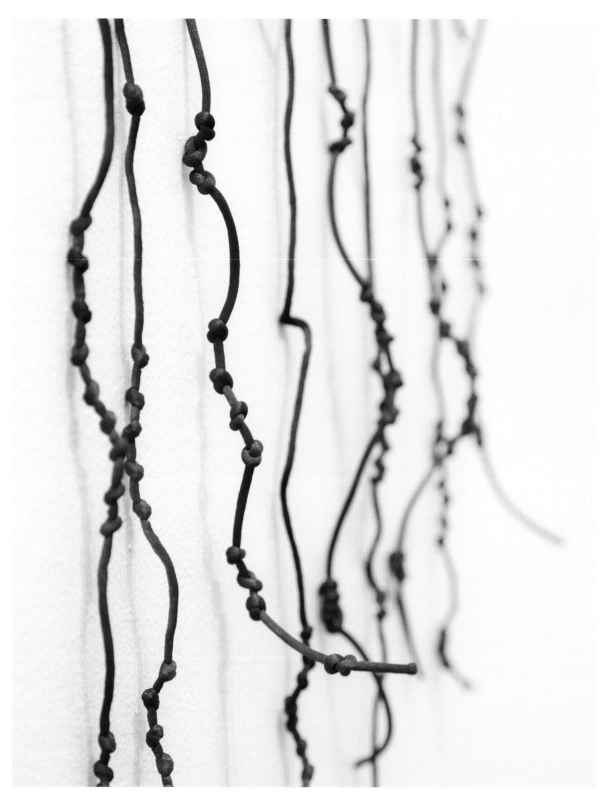

Retracing the Trace (detail), 2012
Cord, ink, pastel

Hill's creative use of *khipu* serves as a metaphor for revitalizing a silenced and endangered Native American language. While a unique form of expression, she also uses the cords as a system to count each woman who would be attacked, who would remain silent, during a twenty-four hour period.[3]

Hill rejects a European language system driven by religious doctrine and expands the spoken word option toward a pre-contact "primitive" worldview, expressing khipu's multi-dimensional potential for expressive language.

As a premise for enlightenment, the development of modern art and the avant-garde in Europe steals the soul of "primitivism" while being intrigued by an Indigenous worldview in four dimensions. In *Retracing the Trace* and through her inspired use of the *khipu*, Hill links time and space across cultures and bridges disparate worldviews. Artists such as Gauguin, Matisse, and Picasso, while inspired by "primitivism," could only express a romanticized version of this other reality.[4]

Hill remains connected to the Qualla Boundary. She was co-director for LIFT Contemporary, Cherokee (2010–11) and co-director/program outreach coordinator for the Oconaluftee Institute for Cultural Arts, Cherokee (2008–2010). She is currently planning a collaborative performance piece with multimedia artist Jeff Marley (Eastern Band of Cherokee), director of the Nantahala School of the Arts for 2016. In addition, Hill continues to collaborate with the Cherokee Language Revitalization Project, Cherokee Studies, Western Carolina University, helping to preserve the Cherokee language by creating illustrated Cherokee language books.

Hill spent her formative years immersed in an urban experience in both Native and non-Native worlds, through which she developed a diverse worldview that inspired her personal and artistic journey. Independent artist, curator, writer, and journalist B. Lynne Harlan (Eastern Band of Cherokee) offers insight into Hill's *The Pilgrimage Ribbon* installation and its link to her traditional and contemporary art interface. Harlan's landmark commentary on the evolution of Cherokee art, *Cherokee Art: A Cultural Journey*, delineates Luzene Hill's place in the cultural lineage.

The Cherokee journey of art is to experience life, witness the emotion through artistic expression and interpret that expression to the audience….it is Hill's expression that elevates the entirety of the Cherokee art journey to a new level. That new level is one in which the very source of our faith and sensibility are drawn together with the old expressions of the Aztec culture. It is this unification of both expressions of knowledge and its importance to contemporary people that reflects that traditional continuum. Hill's works are inspired by her life ways and experiences, but the underlying principle is congruent with her counterparts in art.[5]

Recounting her recent travel to and experience at Palenque (ca. 226 BC to ca. AD 799), the major Mayan state ruin site in Chiapas, Mexico, Hill summarizes her thoughts on the interconnectedness of Indigenous cultures.

Palenque was a peak moment in life for me. I have been fascinated with archaeology and especially an image of Machu Picchu since I was a child. Walking up those stone stairs and seeing that city emerge visually from the jungle was amazing….as you know, when I dissolved into tears. I never thought I would ever visit a place like that—never… then the tomb of the Red Queen just won me over to an admiration of those people who live their lives so connected to the universe….I felt as though they were the kind of people/artists I wanted to be…and then I realized that…technically we were related by bloodline and their worldview could be mine. The Mayan glyphs, the khipu *and Sequoyah's writing system were all based on a non-alphabet written language…and represented a different way of approaching language, art, everything! It has been a touchstone for me—to allow myself to look at things in my own way, while being guided by those examples.*[6]

Hill began making art in earnest during her thirties but did not seriously start exhibiting until 1997. She notes that it was a traveling exhibit of the abstract expressionist painter Willem de Kooning's work that first inspired her to create art that people could experience in three dimensions. "I wanted to be part of the painting, experiencing it more fully," she says,

Above: *Untitled*, 2010
Tea, charcoal on paper

Center: *Untitled*, 2002
Charcoal on paper

Below: *Untitled*, 2014
Collage, ink, pencil on paper

explaining that de Kooning made her want to be surrounded by an artwork, rather than simply taking it in from a distance. "It was thrilling. It was a totally altered state."[7]

In 2015, the First People's Fund awarded Hill an Artist in Business Fellowship, which will enable her to continue collaboration with Speakeasy Press (Dillsboro, North Carolina) to create and illustrate a Cherokee language artist-made book, utilizing a revitalized Cherokee syllabary letterpress typeface.[8]

Hill received a bachelor of fine arts degree (*summa cum laude*) and master of fine arts degree from Western Carolina University in 2012. Hill is featured in Susan Power's book *Cherokee Art: Prehistory to Present* and Josh McPhee's book *Celebrate People's History! The Poster Book of Resistance and Revolution*. She has an extensive exhibition record that includes her recent sculptural installation *Becoming* and was a significant component of *Changing Hands 3*, which opened at the Museum of Arts and Design in New York in 2012 and then traveled to museums throughout the United States and Canada. *Changing Hands: Art Without Reservation 3* featured approximately seventy artists from the northeastern and southeastern United States and Canada who represent a new generation of Native artists utilizing contemporary techniques, materials, aesthetics, and iconography in their art and design practice.[9]

In conversation with Scott M. Brings Plenty of the *Cherokee One Feather* newspaper, Hill observed, "For the Museum of Arts and Design in New York, I created a new seven figure sculpture installation, each adorned with ribbons—inspired by Native American cosmology. *Becoming* [adapted from Hill's earlier *Transparent to Transcendence*] depicts young girls being transformed from humans to stars as they are pulled into the sky to become *The Pleiades* constellation." In 2012, a selection of Hill's intimate mixed media drawings was included in the the Yekaterinburg Museum of Fine Art, Russia, exhibition *Native Art in Russia* and then later featured at the Novosibirsk Museum of Art Biennial, Russia. In collaboration with the Language Revitalization Project/Cherokee Studies at Western Carolina University, she has illustrated three books that were funded by The Cherokee Preservation Foundation. The books are written exclusively in the Cherokee language with no

accompanying English translation to emphasize the language's significance to the Cherokee culture. *The Grouchy Old Lady* (2007) is illustrated with a combination of Hill's collage and pen-and-ink drawings while *Spearfinger* (2008) is illustrated with cut-paper collage. To Hill, these illustrated books are vital to the preservation of the Cherokee language. She noted, "*Spearfinger* is beautifully bound and nicely done....I feel as though the children deserve a first-rate book in their own language." Hill goes on to say, "Art is a language, an individual expression that comes from the artist's core. A viewer of art responds to it from that same place, based on their individual experiences. This communication doesn't require translation."

Luzene Hill's installations are rooted in ideation, layered in concept, feeling, and emotion. Her creative process is demanding, combining personal experience, in-depth research, planning, and implementation. Experiencing Hill's installation is akin to a shared meditation. She invites mutual discovery, expects divergent points of view, hopes for a collaboration of sorts. For Hill, sensing the space, selecting materials, and placing objects can be a mental and physical journey, a laborious process. The experiential nature of the process elicits cross-cultural metaphors, revisits collective memory, and conjures spiritual regeneration.

More than a decade has passed since Hill began exploring the installation format and process, and she acknowledges that time has provided the distance and opportunity for a new perspective on the form of expression itself and the nurturing of initial concepts. In 2006, Hill created her mixed media installation *The Pilgrimage Ribbon*, featured in the inaugural exhibition season for the new Fine Art Museum at Western Carolina University. Hill's purpose is clear, yet she weaves a complexity of visual and conceptual elements, resulting in a highly expressive and provocative statement. Hill comments on the process and inspiration for *The Pilgrimage Ribbon*.

> Pilgrimage... *explores journeys and the loss of Native American Culture. One component of this installation, two accordion format books, references the Codex Boturini—that visualizes the Aztec's journey to find a home. My two codices (11 inches high by 11 feet long) represent*

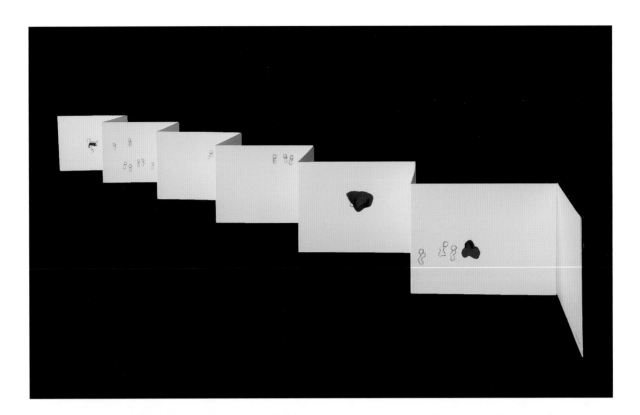

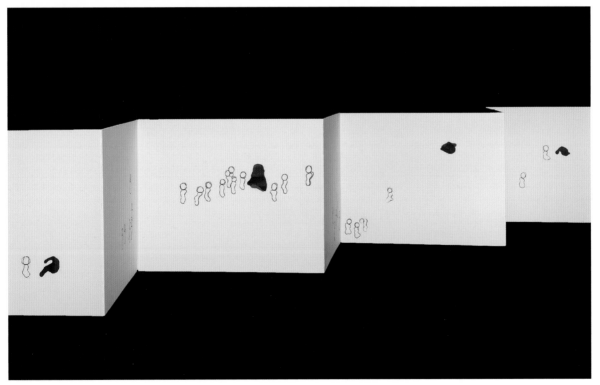

Above: *The Pilgrimage Ribbon #1*, 2005
Paper, charcoal, ink, museum board, book cloth

Below: *The Pilgrimage Ribbon #2* (detail), 2005
Paper, charcoal, ink, museum board, book cloth

my own journey during an eleven-year period and the journey we all have in common, as we make our way through life, its foibles, our foibles—vulnerability expressed by the negative space in which the figures and shapes exist. Our paths dip and wind through encounters, exploration, danger, disappointment; eventually straying into uncharted areas of ourselves. . . .

Tira de la Peregrinacion is the Spanish name for Codex Boturini and translates as "The Pilgrimage Ribbon." The dictionary defines pilgrim as "one who embarks on a quest for some end conceived as sacred." "Pilgrimage Ribbon" further translates into Cherokee "as I look for the important things." This phrase captures the focus of my work in which I correlate the Aztec's pilgrimage with the journeys we all travel in life.

My drawings in the two accordion books (codices) mimic the stylized images in Codex Boturini, explore my own journey over an eleven-year period. The drawn figure moves along, meandering as I made choices, some wise, some not. Red ink appears as I confront life; its ambiguity, paradox, uncertainty, passion.

The sculpture in the center of the gallery is comprised of 484 (twenty-two times twenty-two) manuscripts stacked one upon the other. Creating these codices involved tearing, staining, drying and folding 484 strips of paper. This process gradually became a meditation, a journey within as I reflected on things lost – personal, societal, cultural. During the exhibition I will randomly return to the gallery and "steal" codices until twenty-two remain, drawing attention to the expanding empty space as Native American culture disappears.[10]

In her installation *Transparent to Transcendence*, Hill offers an exquisite rendition of the phenomenon of transformation, from physical to spiritual. Hill says,

Many tribes have retained stories that explain celestial constellations that involve children being drawn up into the sky. I especially like the Kiowa story, as told by Scott Momaday, in which seven sisters become the stars

of the Big Dipper. A similar Cherokee story tells about children ascending into the sky to become the Pleiades constellation. Both suggest their subjects moving effortlessly and unafraid through their transformation process. Transparent to Transcendence *presents seven beeswax figures suspended at varying heights, in the formation of the Pleiades. These adolescent female figures are being drawn into the night sky, appearing to freefall up.*[11]

Hill notes that her installation . . . *the body and blood* was the most political piece she had created up until that time. In 2010, Hill was invited to create work to coincide with an event at the University of North Carolina, Asheville, called "Visualizing Human Rights." She comments:

> *As a survivor of rape, I was at first hesitant to address the issue of violence toward women. I was concerned that I may not have enough objectivity to make art on the subject without it becoming sentimental or all about me. . . . I realized that the work is not about me, it's about all women. The statistics that informed this installation addressed violence toward women as a global issue. . . . However the incidence of violence toward women in Native American communities is appalling. Attacks and rapes are three and a half times the national average and at least 70% of the attacks involve non-Indian men on Indian women.*[12]

For the Eiteljorg Fellowship exhibition, Hill re-examines her *Retracing the Trace* installation that she initially created for her master of fine arts thesis exhibition at Western Carolina University. While Hill's intention and inspiration remain essentially the same, the space and form of the installation have evolved. In addition, a collective memory now exists of *Retracing the Trace* by previous viewers who experienced the installation at an earlier time and different location, which adds to the equation and expands the impact that it potentially may have on a current viewer's experience. Due to the duration of the Eiteljorg exhibition, Hill has incorporated video as a creative element, to document not only the passage of time but also the creative process, thus enabling her constant presence as an expressive element in the gallery. Especially meaningful here are Hill's comments about the in-depth process of creating *Retracing the Trace.*

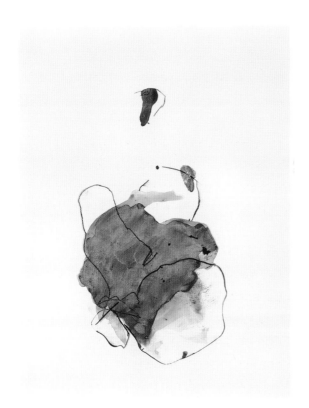

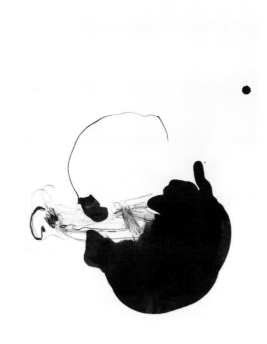

Above left: *Untitled*, 2010
Tea, charcoal on paper

Above right: *Untitled*, 2010
Tea, charcoal on paper

Below left: *Untitled*, 2013
Collage, tea, charcoal on paper

Below right: *Untitled*, 2014
Ink, charcoal on paper

Luzene Hill 51

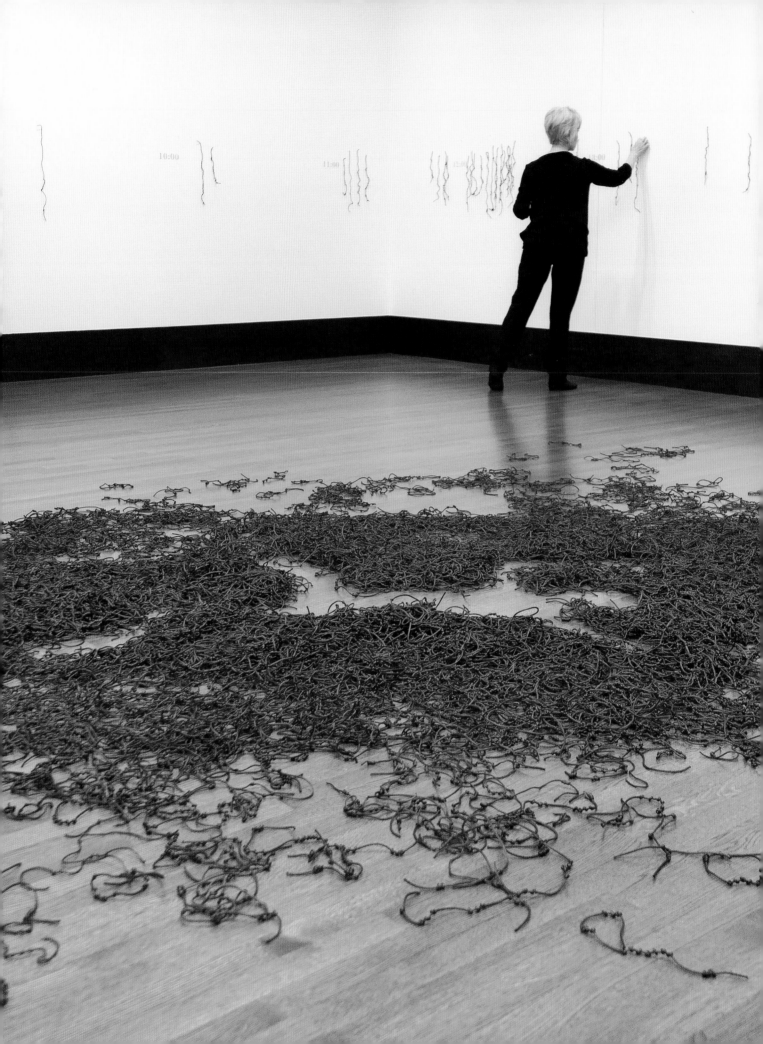

Silence shrouds the experience of sexual assault. A woman is often strangled to silence and control her and the aftermath is characterized by a different kind of enveloping disquiet.

On January 4, 1994, I was attacked, beaten, and raped in Piedmont Park in Atlanta. Rape is not about sex, it's about power and rage. A woman is made powerless, and she is silenced. The rapist grabbed me from behind by the hood of my jacket and strangled me with the cords tied around my neck. Those traces of violence remained on my neck for six months. I thought they would be there forever, constant reminders of the assault, and permanent reminders of being silenced.

Retracing the Trace *has three components. Numbers, indicating each hour in a day, were stenciled in a line around the gallery walls—at the height of my neck. Material volume, knotted cords, pooled on the floor around the outline of my body and re-presented the traces of violence left in the leaves and mud where I was attacked. Each cord signified a specific number between one and 3,780, the estimated number of unreported rapes that occur in the United States each day. I borrowed principles of the Inka khipu, an ancient cord knotting system used for accounting and storytelling, to count and give voice to those women who remain silent. The third element was my daily ritual/action of moving a portion of the cords from the floor to the walls.*

In previous work, I addressed the issue of violence toward women in an abstract and personally detached way. Retracing the Trace *marked a shift in my approach to making work about this issue. Each aspect of this work reflected my identity and involvement, from making the body imprint to removing the last cord from the floor and attaching it to the wall. The gallery was a metaphor for my body.*

In developing Retracing the Trace, *I returned again and again to the idea of cords. The original cords on my jacket had silenced me, and traces of that silencing haunted me each day as I looked in the mirror. The streaks on my neck were the visual evidence of being strangled,*

Opposite: *Retracing the Trace* (detail), 2012
Cord, ink, pastel

silenced, and controlled. I wanted to turn that around and use cords for tracing a voice that would break the silence. The khipu *gave me a device to do that.*

Recent research on the khipu *suggests a theory that the Inka had a method of communication equivalent to a written language. My goal was not to create replicas of the* khipu, *but to use that system of counting to represent each woman who would be attacked, and remain silent, during a twenty-four hour period. Each of the knotted cords in my installation was a specific number designation, one through 3,780, based on the knotting principles of the* khipu. *The cords I created followed that system precisely, in order to make each cord unique, specific˙AND countable.*

I used three diameters of satin cord, which were similar to the size of the cords that had strangled me. I first knotted each cord, then dyed them several times with ink and stain. Retracing the Trace *also reflects Ana Mendieta's work, especially her* Silueta *series, which involved Mendieta being covered with flowers, grasses, or snow. I used that model to create the floor piece at the beginning of the exhibit. I lay on the floor and had the 3,780 knotted cords scattered on and around me.*

I then got up, allowing the cords on top of me to fall around the space. After repeating this process, in different positions, the result was an image of the cords pooling around the imprint of my body slumped on the ground.

This is the first day. The walls are completely empty except for the hours in a day—1:00 through 24:00 hours stenciled around the walls, at the height of my neck.

I placed the first group of knotted cords on the wall between the 7:00 and 8:00 hours because that is the time of day I was attacked. After that, the cords were placed at random, to reflect the random nature of sexual assault.

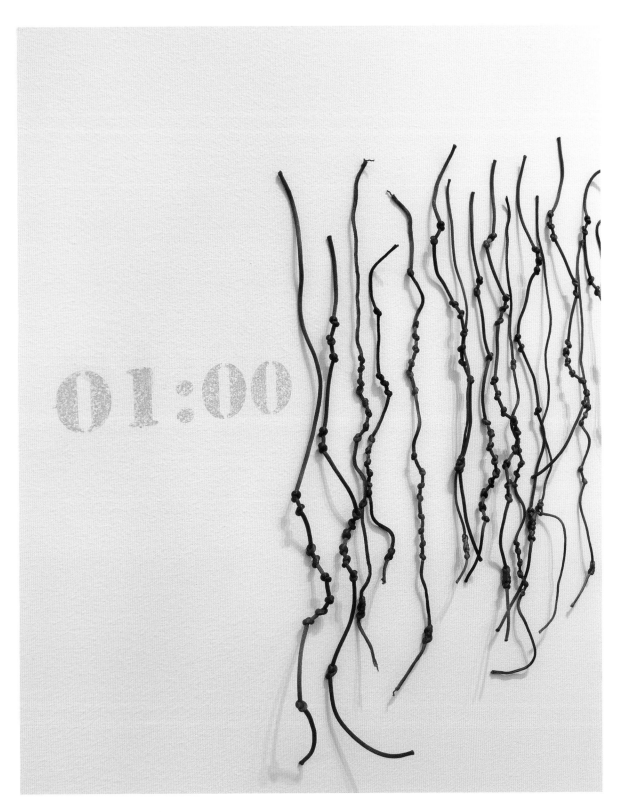

Retracing the Trace (detail), 2012
Cord, ink, pastel

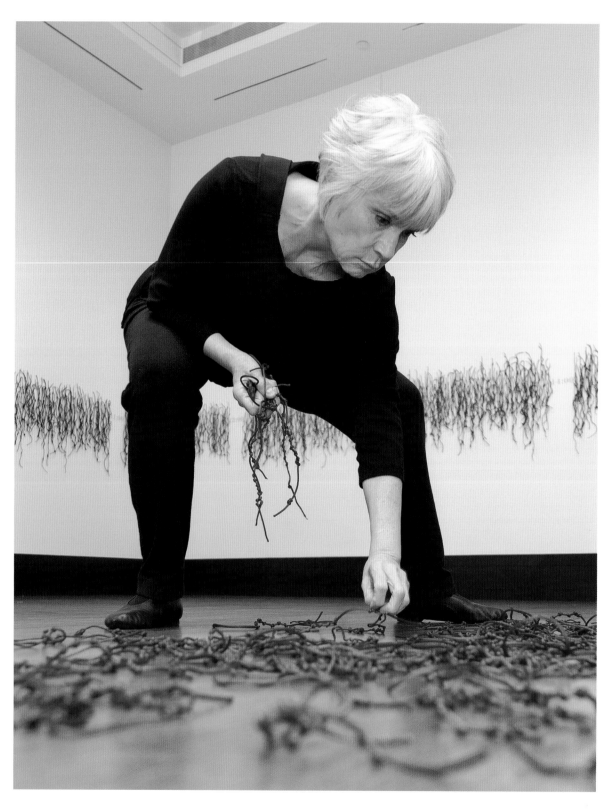

Retracing the Trace (detail), 2012
Cord, ink, pastel

By the last two or three days of the exhibit, the floor imprint had been diminished in depth and volume. The remaining individual cords were more scattered and separated. Each cord configuration and knot pattern was more apparent and the imprint displayed an increasingly delicate figure. On the last day the walls were encircled with a solid and intense trace, above the vacant gallery floor.

I had resisted my personal experience being the primary focus of this work because I believed it would put the spotlight on me, rather than on the issue of sexual assault. And I am not interested in presenting "confessional/victim art".... My own response to Ana Mendieta's Siluetas had been a personal recollection of the mud and leaves where I had been attacked. I made an immediate, visceral connection to the imprint she had created with her body and the imprint of my body I had seen on the ground. Marina Abramovic's ritualized actions provoke identification with her endurance and her vulnerability and an acknowledgement of our own vulnerability.

Being alive is being vulnerable.

Accepting vulnerability—courting it—embracing it—for ME—is essential in order to make art.[13]

Hill is an artist whose creative work is an all-encompassing poetic read. It communicates wonder and expands the viewer's attention on an experiential level—the reward is simply synaesthetic. In its thought-provoking and multi-layered form and content, Hill's visualization of the world earns a significant place on the map in the current trans-global cultural landscape. Amid an intensifying contemporary conversation on Native American fine art, Luzene Hill's cross-cultural journey and continuing exploration of interconnectedness most assuredly inspires thought and action in the face of change.

[1] Luzene Hill, "Abstract," *Retracing the Trace* (master of fine arts degree exhibition), Western Carolina University, October 2012.

[2] Ibid.

[3] Ibid.

[4] "Picasso, Primitivism, and Cubism." Boundless Art History. Boundless, 05 Jan. 2015. https://www.boundless.com/art-history/textbooks/boundless-art-history-textbook/europe-and-america-from-1900-1950-ce-36/european-art-223/picasso-primitivism-and-cubism-788-6925/, accessed April 29, 2015.

[5] B. Lynne Harlan, "Cherokee Art: A Cultural Journey," *The Pilgrimage Ribbon* (Cullowhee, NC: Fine Art Museum at Fine and Performing Arts Center, Western Carolina University, 2005), 9-11.

[6] Artist's personal communication with author, March 18, 2015.

[7] Artist's personal communication with author, March 19, 2015.

[8] Rose Garrett, "OICA Letterpress to Print Cherokee Syllabary," *Cherokee One Feather*, January 15, 2010. http://theonefeather.com/2010/01/oica-letterpress-to-print-cherokee-syllabary/

[9] "Contemporary Native North American Art, Changing Hands 3 at The Museum of Arts and Design in New York City, June-October 2012," Art of the Times, March 28, 2012. ww.artofthetimes.com/28/3/2012)

[10] Luzene Hill, *Retracing the Trace* (master of fine arts degree exhibition), Western Carolina University, October 2012.

[11] Ibid.

[12] Artist's notes, "Knoxville Art Museum Talk," personal communication with author, March 18, 2015.

[13] Ibid.

Untitled, 2013
Collage, ink, tea, charcoal on paper

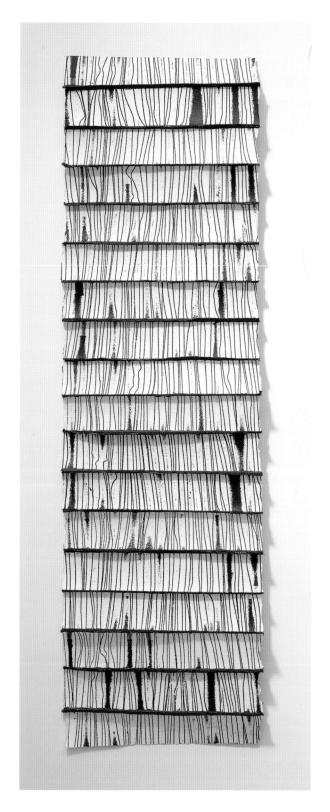

Rifts #2, 2015
Collagraph print, thread, encaustic on rice paper
Image courtesy of the artist

Brenda Mallory (Cherokee Nation):
Ontology of Ripples

By heather ahtone (Chickasaw and Choctaw Nations of Oklahoma)

The connections between things and people are mapped in many ways, expressing the interdependent relationships that bind all forms of life into a complex web. A network of relationships covers the surface of the earth and is often found in cartographic charts. These maps can take many different forms, including Beck's maps, Gray's anatomy charts, or traditional Lakota beadwork designs. Abstraction is often used to communicate the complexity of these connections, expressing various relationships through color, line, and form that might otherwise be too difficult to comprehend. Brenda Mallory (b. 1955, Cherokee Nation) explores those relationships through sculptural forms reverberating with tension as she enunciates the microcosmic relationships between cellular structures and the macrocosmic spheres of power and identity.

It would be essentializing to say that Mallory's art is all about her cultural identity, largely because the complexities explored within the objects includes that identity, as well as everything from motherhood to Monsanto. It is truly the simplicity of the forms that build into complex structures that make them so engaging. One need not be versed in anything that Mallory is thinking to recognize the references to the interior of cell structures. Mallory's titles encourage us to consider the forms as part of the semiotic dialogue examining nature's fluidity: *Reformed Order*, *Low Tide*, *Rifts*. She moves us to think of natural ebbs and flows and the sheer necessity of water as a primal element. Their overt simplicity is part of the draw, engaging viewers to closely consider their construction.

These forms are made from simple materials—largely cotton flannel, cotton thread, pigments, and wax. The layers of cloth start out soft and pliable—responsive to her touch—as Mallory prepares the cloth, either selecting scraps from her previous projects[1] or intentionally cutting sections from a raw bolt. She constructs the independent parts by sewing together flannel pieces, at which point the seams often become an important linear mark. After she sews the cloth parts together, often into a boat-like form, she dips the singular units into a skillet of melted wax, an encaustic process she evolved through experimentation. The wax-laden form is then withdrawn from the warm wax and gently shaped as the wax cools, then burned with a torch until the form responds to Mallory's guiding hands. This dipping and reforming is repeated three times to become the durable form that can hold its own shape and the shared weight of its neighbor parts. This transformation by fire results in individual parts that have lost their pliability and become quite durable. When assembled, these parts have the potential to become something that reads as larger than life.

This is evident in *Undulations (Red)* (2012), with its rows upon vertical rows of the same boat-like forms that read like opened pods in varying shades of Italian Pompeii red, raw sienna, and yellow ochre mixed into the encaustic. The cloth forms are bolted together along the edges with nuts and bolts that resemble seeds waiting to emerge. The delicate edges of each pod look naturalistic, as if borne from a cycle that yearns to become verdant again. A welded, metal support that goes largely unseen is attached to the collected forms from behind. Just the tips of the metal reach past the terminal edge of the cloth, like tendrils emerging and reaching vine-like to connect with the wall behind. The rows retain some regularity that emphasizes the slight variations in the pods while activating the playfulness of the sculpture. Mallory states that she enjoys these unique characteristics:

> *All of these little units that the sculpture is constructed of; they are basically all the same unit. But they don't look exactly alike and I think of that as a metaphor for humans, or members of any species. And how, to aliens looking down on us, we all look the same. It is through getting to know each one that we appreciate individuality.*[2]

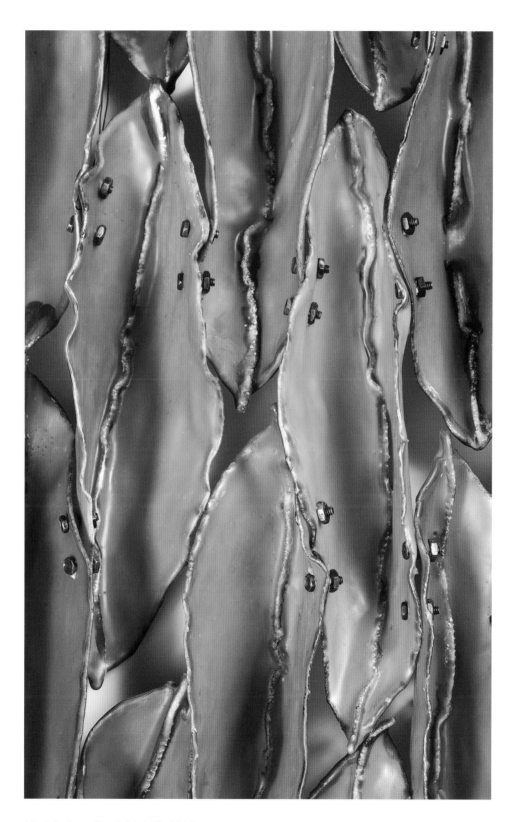

Undulations (Red) (detail), 2012
Waxed cloth, nuts, bolts, welded steel

Perhaps it is the examination in the similarities and differences of the many that draws a metaphor to the foundation of relationships. She takes pleasure in getting to know the parts and the joy of assembling them. Her pleasure in the construction is matched by her passion and commitment to addressing issues related to seeds and regeneration.

Mallory often references science through her titles and the forms themselves. She has posted an early body of work on her website titled *Biophilia,* consisting of interpretations directly drawn from a biology textbook into sculptural form.[3] The concepts of science and cellular structures continue to inform her work. She follows science journalism, an avid personal interest, but she refuses to leave her ideas at that simplified account. Her interest in science stems from growing up in an agricultural family. Her childhood memories are full of the local environment around Claremore, Oklahoma, and the intimacy inherent from that earthen engagement in planting and harvesting. She was raised with an acute awareness of the relationship between sown seeds and the resulting harvest. As she has matured, this awareness has grown to include the human dependency on natural cycles and the influence that greed can have on the viability of fertility. These issues came into play when Mallory recognized the symbolism of those natural cycles for fertility in her daughter's emerging puberty and her own declining fertility. The personalization of fecundity combined with her ecocentric perspective became an important source for her continued conceptual development.

The art that expresses this symbolism has been a commentary on the natural cycles of fertility and her outrage over the emergence of Monsanto's terminator seed technology. The much-reviled corporation has developed a process of creating seeds with a single fertility life-cycle, so that any seeds produced from the first sowing are rendered sterile as a form of genetic use restriction technology (GURT). Using these seeds subverts the natural cycle of food production and risks potential economic disaster for communities dependent on reseeding for continued production.

Monsanto's initial experiments were with cotton and tobacco seeds that were tested in Africa without accepted field testing protocols intended to protect the hybridization of their seed with local farms. Suman Sahai describes this technology in her article for *Economic and Political Weekly*:

In principle this sterility-inducing mechanism can be incorporated into any kind of crop. The next round of crops that are to be tried out are essential food crops like rice, wheat, pulses, and millets. If the terminator technology should be successfully transferred into these crops (and there appears to be no reason why it cannot), the implications for global sustenance and food security could be quite horrific. Rice and wheat are the staple food of three-quarters of the world's population.[4]

This kind of genetic modification to basic food staples has global implications for food security, the capacity of a nation to secure and provide food sources for its citizens. The extension of this concern is that these same vulnerable nations would be at risk for weakened political sovereignty, with undue dependencies on corporate engagement and host-nation charity. Mallory finds this kind of technology "appalling on so many levels." The immediate body of her art addressing that topic was a piece composed of forms that used spent shells as a metaphor for infertile seeds called *Demeter Does the Math and Cries* (2000). Referencing the Greek mythological figure whose daughter is the personification of vegetation, Mallory felt that this story resonated with her own experience as a mother and the potential risk of future food sources being endangered. This piece was the first made from cloth scraps repurposed with wax.

Since this initial experiment, Mallory has continued to work with the cloth forms and the encaustic process, steadily manipulating the materials and her ideas to elaborate on that relationship between simple life forms and power. As described, Mallory has been working through the organic nature of forms and cellular relationships. She is currently striving to impose more structure, seeking to create sculptural systems that relate to nature but also explore "…how when something goes awry, the resulting repairs form interesting systems themselves."[5]

In *Reformed Order* (2013), the organic structure has become more organized and symmetrical. The pods have given way to pipe-like structures, with sewn pin-tucked pleats traveling the length of the vertical forms, emphasizing the linearity of the structures, which have become more complex. Mallory embraces the unbleached color of the cloth, generally

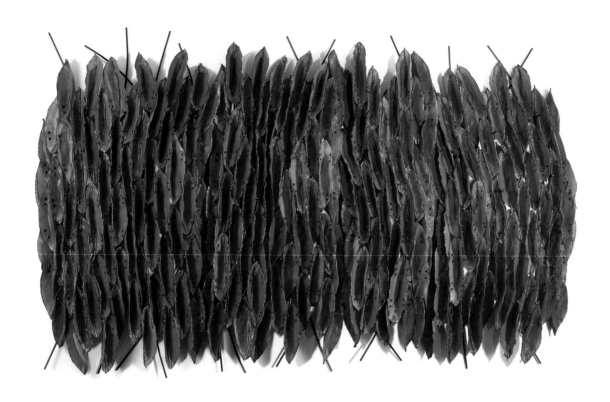

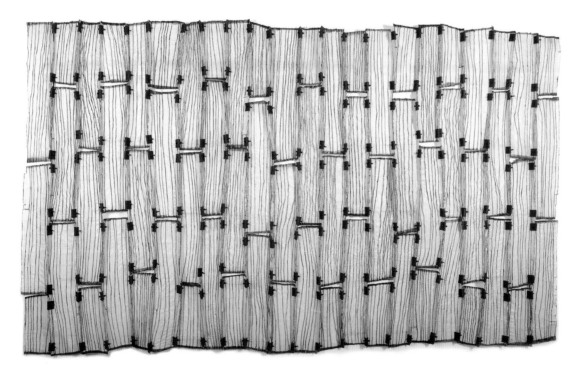

Above: *Undulations (Red)*, 2012
Waxed cloth, nuts, bolts, welded steel

Below: *Reformed Order*, 2013
Waxed cloth, felt, nuts, bolts
Images courtesy of the artist

speaking, and in this sculpture, the pleats are emphasized as dark lines, relating them to the color of the nuts and bolts. The metal pieces that bind the terminal ends of the pieces centrally to the adjoining walls resemble the joints of river cane. If one were to compare *Undulations (Red)* to *Reformed Order*, a case could be made that it is the difference of looking through a microscopic lens at different magnifications, going from looking at a cellular structure in the former to a broader image of tissue in the latter. Mallory's exertion of control seems to be one of both aesthetic conscience and an extension of testing the limits of the materials and their weight-bearing capacity. If she is testing the limits of this cloth, is this a metaphor for something more personal?

In speaking about her art and fertility, the issue of identity was subtly entangled in the conversation. She has recognized that her experience as a Native American is part of a broad spectrum of Indigeneity, that her disconnection from the culture was not something she feels she had any power to prevent and something she has struggled to reconcile through her experience. Mallory represents a portion of the Native American diaspora who live away from their tribal nations, despite being within the U.S. boundaries, and who experience feelings of separation and isolation. Driven by her personal interest in validating this part of her identity, Mallory has participated in Cherokee at-large classes offered through the local university to connect, however distantly, with her tribal history. She has recognized that this feeling of disconnection is not hers alone, that the isolation was the result of federal policies designed to force families into assimilate to American society. She stated, "It's not an accident that the tribal culture for some has become so disparate and disconnected. It was an absolute plan." She recognizes that American nationhood "is often celebrated through patriotism, but we have built this nation on policies of greed and taking advantage of people."

Mallory recognized that the application of terminator technology would have a similar effect on seeds as the U.S. federal assimilationist policies had on Native cultures. Both were motivated by greed. Both would potentially have a homogenizing effect and would weaken natural orders. Mallory sees herself as a product of those assimilationist policies. As she saw her daughter emerging into a young woman who would eventually raise another generation, she saw that the federal policies had contributed to another generation being

removed from their Cherokee community.[6] Those assimilationist policies that were initiated following the Removal Era had a profound effect on both her maternal and paternal families.

Mallory's paternal family participated in the Cherokee tribal enrollment process and, as Mallory stated, "My community assimilated fast and hard. In my family, we didn't practice Cherokee culture." The Chambers family members from whom Mallory is descended were likely attempting to protect their children from suffering as Indian children by adopting farming and other social practices that federal agents were encouraging across Oklahoma during the late nineteenth century. While Mallory's paternal family members have retained their tribal citizenship through generations, even actively identifying as Cherokee, their connection is largely historic. Over generations, they have become separated from the culture while remaining in the local area of the Cherokee Nation. Although it is believed they were eligible, her maternal family did not participate in the Dawes enrollment. The exact circumstances are unknown, but they may have been like many families (including my own) for whom the choice to enroll as less than their actual quantum was an act of self-determination to retain land and property rights not yet afforded the Native American community. Over generations, that inevitable deterioration of eligible blood-quantum has played into reality to the extent that the family recognizes descent through her mother, but not with a formal tribal affiliation. Those federal assimilationist policies have created a cultural infertility in her family that Mallory internally struggles to reconcile. Mallory saw that Monsanto's terminator technology would have the effect of the seeds losing their identities and consequently their capacity to generate new life as a species. The terminator seeds, like the assimilated Native American diaspora, threaten us with impotent cultural life.

One can see this metaphor between policies and technology played out in *Colonization* (2003). Each boat-like part, which can read as much as a folded leaf as a vulva, gently curves inward, a seam bisecting the vertical, concave form. Each form is hardened independently of those around which it will be bound. It is hardened through repetitive exposure to layers of hot wax until it no longer bends to the touch. In the same manner, Indian people became hardened, enduring suffering as a result of their being Native.

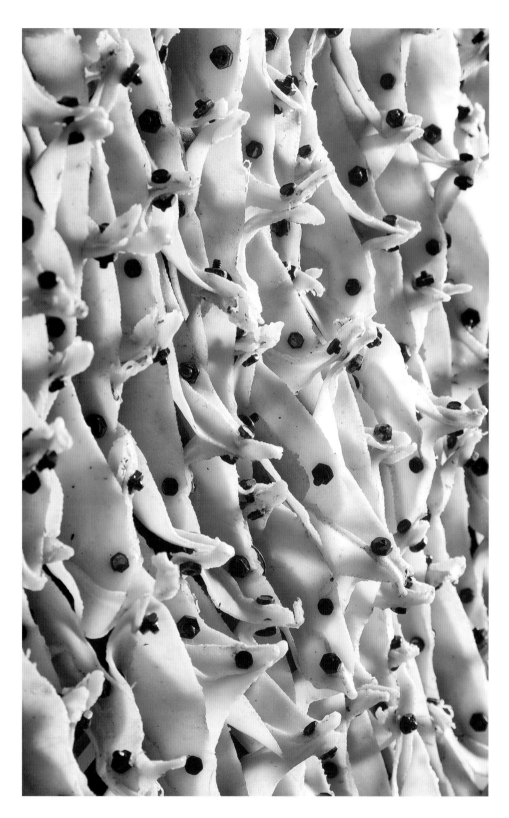

Colonization (detail), 2003
Waxed cloth, nuts, bolts

Mallory's family, like many families, encouraged their children to adopt Euro-American customs and practices as a survival mechanism. Similarly, after the parts are completed, Mallory drills through the hardened forms to create a site for inserting the binding mechanisms. Once the surface is broken, the multitude of these individual parts are connected to one another with nuts and bolts. This penetration can be read as a metaphor for assimilationist policies that pointedly attacked many Native families, leaving holes in their cultural identities.

The effects of colonization, both cultural and viral, interest Mallory. "I was thinking about colonization under a microscope…and the bigger picture of what colonization is…I'm always thinking of how something spreads." She is acutely aware that imperialist expansion spread across the continent, weakening Native ways of being. The spread of colonization for many communities was facilitated by decades of federal policies after the imposition of removal, through boarding school, termination, and relocation policies that continued into the 1980s. Each layer of separation contributed to the dispersion of Native American diaspora across the continent.[7]

Mallory is part of a largely invisible Native American diaspora who reside in large urban spaces away from their tribal communities. Having settled in Portland, Oregon, Mallory is one of the 78% of American Indians who live in urban places, physically separated from their culture and surviving at a distance.[8] "I've always read about, cared about being Cherokee. But I'm not directly connected." She has struggled with self-identifying as Cherokee because of the separation from the tribal community that she inherited. However, while she was not recognizably Cherokee, this remained an important part of her own sense of being. Like many Native Americans who phenotypically do not resemble their tribal community, Mallory was cautious to self-identify as Cherokee because she did not want to be perceived as a "wannabe." She has worked to remain aware of Cherokee politics, actively participating from a distance and always feeling conflicted about the political discord, about which she stated, "That's the state of being an out-of-state Cherokee."

Her experience is too common to dismiss as invalid, although it is often subjectively measured against what is perceived as an "authentic" form of being Native American. If her community formally recognizes her as a citizen,

which the Cherokee Nation does, is her experience of separation and isolation from the community not still a part of that broad spectrum of Indigenous experience? One can imagine that at the point of contact with imperialist expansion, the impact of colonialism created ripples across the waters of Native experience. These ripples represent levels of cultural separation, loss of language, and reduced sense of identity—of *being* Cherokee. These ripples have traveled across time. Mallory is part of a large community of Native Americans who are several ripples removed from the fluent speakers who practice tribal traditions, retaining the cultural core that gives their community the means to "be" whoever they are, whether Cherokee or any other community. People like Mallory sit on a far ripple, as Native American diaspora who self-identify and recognize their relationship to their community, with honesty as strained as that ripple may leave them. However, much of their cultural circumstance is the result of decisions made by family members' generations before them who succumbed to the effects of the oppressive federal policies—not because they were not strong, but because they were trying to survive.

In many ways, this effect can be seen expressed in *Interrupted Forms #2*, in which the lineage of culture is sporadically broken and the relationship between forms is tangential, with brief points of contact. While the hollow structures can be seen as a conduit for culture, the periodic breaks in the forms reveal their vulnerability and emptiness. However, *en masse* they form a community, like the large urban communities in which intertribal cultural participation becomes a significant affirmation of culture. Individually separated from their own tribal communities, Native American diaspora bond together and form a cohesive whole that still supports that culturally driven identity. The extension of the supports reach to create new roots and points of attachment.

It is from this interpretation that Mallory's works might be seen as hopeful discourse on the effects of policies that were intended to render an infertile future for Native people. In the same manner that nature has a manner of regeneration, healing after extended periods of decay or decimation, Mallory's art suggests that same kind of cultural renewal is possible for Native Americans. Those vine-like extensions in *Undulations (Red)* reach to make connections beyond the structure's limits. Likewise, Mallory's very application

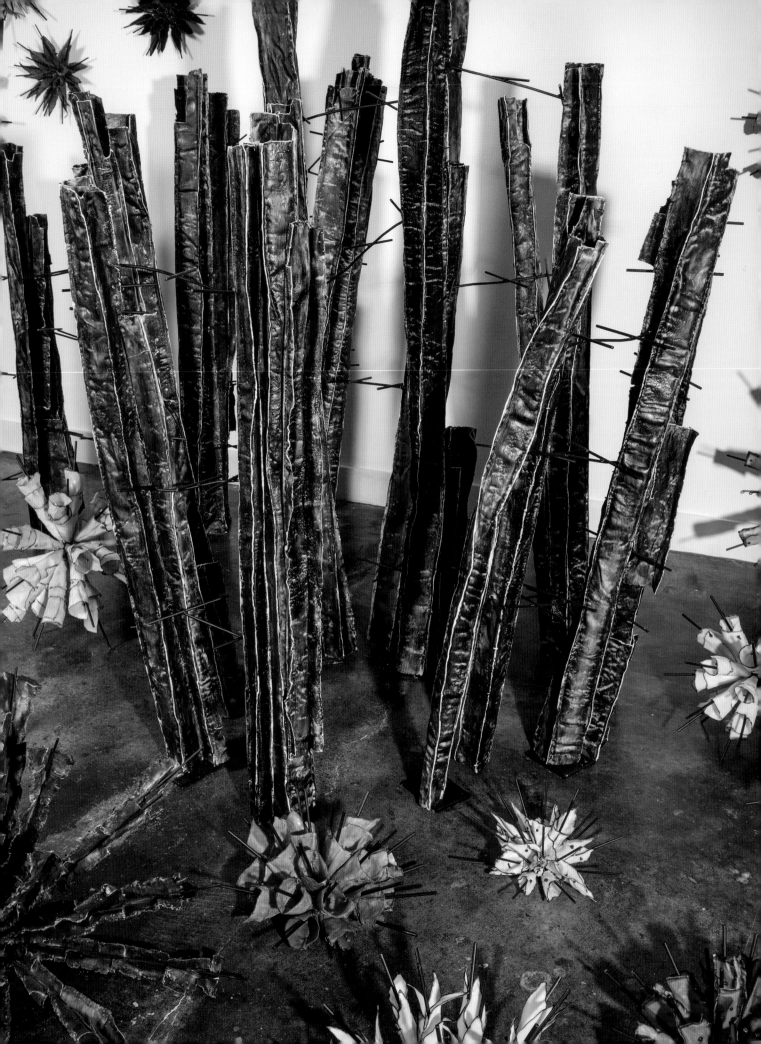

to the Eiteljorg Contemporary Art Fellowship indicates her search for recognition and connection as a Native artist.[9] By seeking recognition for her art, she was also seeking a kind of validation for her experience and identity. This was an act of self-determination for which she refused to accept that she was not worthy.

References to healing continue in other assemblages. In *Reformed Spools*, industrial spools are deconstructed by a vertical slice through all the layers of thread, creating frayed edges and exposing their soft fragility. Dark vertical columns composed of the sliced inner spools read as vertebrae, recreating a sense of healing strength to this reconstructed form, binding across generations of disconnection, fostering healing. Furthermore, these spools travel across the wall connecting the earth to the sky, acting as a remedial patch to the damage that humans transgress in that sacred space, both against nature and our own humanity.

But nowhere is that hopefulness more evident than in *Recurring Chapters in the Book of Inevitable Outcomes*, an installation that juxtaposes somber ruin-like forms standing like charred timbers or a burned-out dwelling with radiating spore-like forms of metal and wax that dance across the floor into the viewer's space. Vibrant colors explode through the biotic flora made from that same pliable flannel and treated with pigmented encaustic. The forms emerge from the floor and the wall, and some connect through their extended metal supports across the space. From the same materials used to consider that internal, cellular experience, Mallory plants a garden of renewal and joy. Working like a beadworker, she assembled the forms with an attention to repetition and pattern, offering a variety of shapes and extensions, each bound together at the core. They may be suggesting that the vitality of the cultures continues to live beyond the impositions made against them at their cellular level, continuing to have a beauty and uniqueness that is valid in the contemporary experience. As each form reaches into the space, it creates multiple points for engagement, suggesting a vitality that celebrates its own survival. As part of the extended community, one might read this as a metaphor for Mallory's own potential capacity to heal across generations and reconnect with her culture.

Opposite: *Recurring Chapters in the Book of Inevitable Outcomes* (detail), 2015
Waxed cloth, hardware, nuts, bolts, steel
Image courtesy of the artist

It is in the multivalency of the parts and the forms that Mallory's work is most potent. While her initial impulse is to respond to the "politics of greed" evident in the federal policies and Monsanto's technology, the range of sculptural forms evokes an appreciation for that internal and external response to these forms of oppression. Beyond just the subjectiveness of that oppression, Mallory is exploring the relationship that exists between the individual parts and the community that is constructed from a bold collective of forms. She is breaking the tissues down into their cellular parts and rebuilding them with an eye toward their new strengths in combination. That resonates on levels overtly aesthetic and covertly ontological. Mallory may very well be skipping stones across those ripples of cultural separation, each dancing assemblage celebrating the strength found in being part of something larger than oneself. At their core, these objects engage us through their simplicity and challenge us to think of the bigger picture. From the perspective of thinking of the single unit and its relationship to the network within which it participates, Mallory provides a map for addressing the issues of being and identity. Certainly at a time when culture is ever more homogenized through media and nationalistic movements, these issues merit consideration.

[1] In 1991, Mallory began a business called Glad Rags, constructing reusable menstrual protection pads from cotton flannel. Although she no longer owns this business, the multitude of scraps left from making these products continues to be used a resource that she integrates into her art. Her commitment to reusing these scraps is part of her fundamental commitment to being a responsible citizen of the earth. Interview with Brenda Mallory by author, March 14, 2015.

[2] Ibid.

[3] www.BrendaMallory.com

[4] Interview with Brenda Mallory by author, March 14, 2015.

[5] Ibid.

[6] Suman Sahai, *Economic and Political Weekly* 34, no. 3/4 (Jan. 16-29, 1999): 84-86.

[7] For further reading on the imposition of federal policies on Native American communities, see Roxanne Dunbar-Ortiz, *An Indigenous Peoples' History of the United States (ReVisioning American History)* (Boston, MA: Beacon Press, 2014). For further reading on the Native American diasporic experience, see Philip Deloria, *Indians in Unexpected Places* (Lawrence: University of Kansas Press, 2004).

[8] U.S. Census Bureau, "The American Indian and Alaska Native Population: 2010 Census Briefs." GovDocs: January 2012, <www.census.gov/prod/cen2010/briefs/c2010br-10.pdf>.

[9] Mallory informed me that her application for the 2015 fellowship cycle was her third attempt to receive the award.

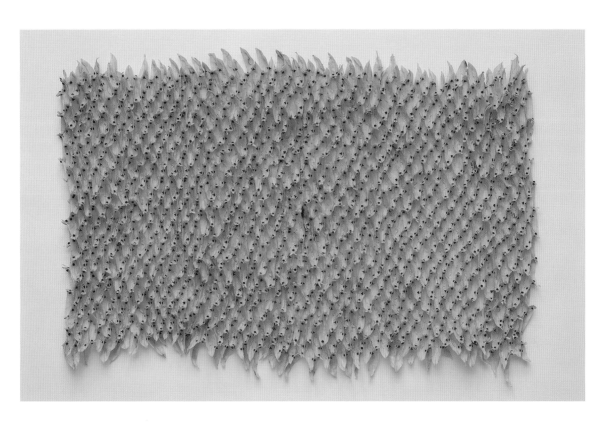

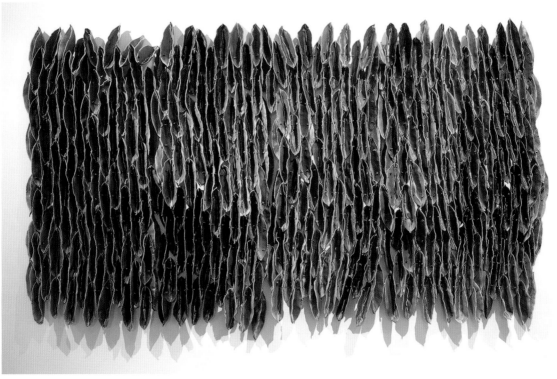

Above: *Colonization*, 2003
Waxed cloth, nuts, bolts

Below: *Low Tide (Dark)*, 2007
Waxed cloth, nuts, bolts, welded steel
Images courtesy of the artist

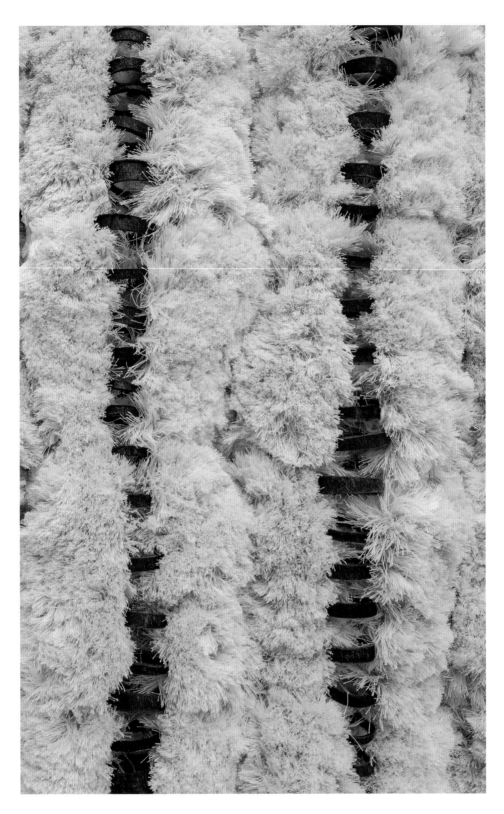

Reformed Spools (detail), 2015
Thread on wood panel, rubber
Image courtesy of the artist

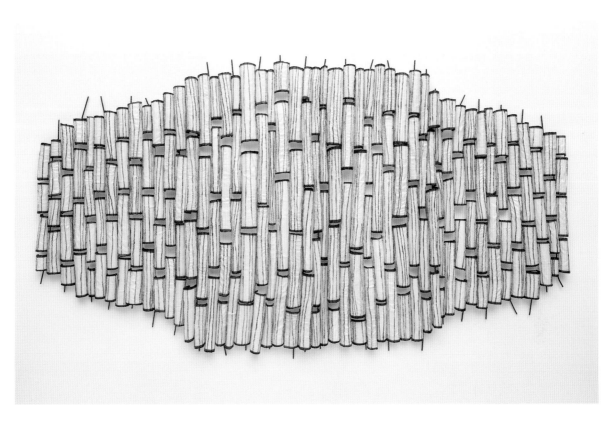

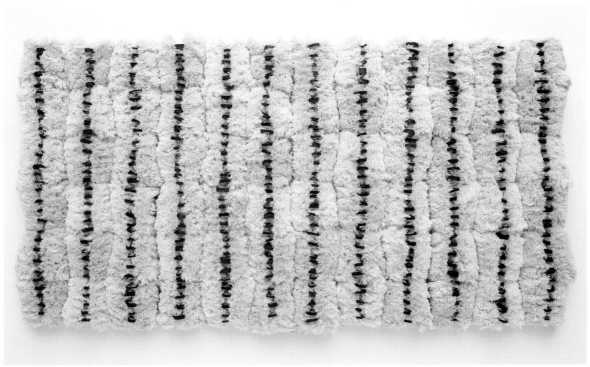

Above: *Interrupted Forms #2*, 2014
Waxed cloth and steel

Below: *Reformed Spools*, 2015
Thread on wood panels, rubber
Images courtesy of the artist

Brenda Mallory 77

Gaaw Kootéeyaa 1, 2, 3, 2014
Wood, rawhide

Da-ka-xeen Mehner (Tlingit/Nisga'a):
Looking into Himself
By Aldona Jonaitis[1]

*I've never wanted to speak for anyone but myself. Sometimes you're put
into the role of speaking for a group — your clan, Alaskans, Native
people. I don't want to be accused of speaking for anyone else.
So my art is from my voice, my perspective. I want to speak for myself.*
—Da-ka-xeen Mehner

Both democratized and brought to the edge of absurdity and
meaninglessness in the form of the "selfie," the artistic self-portrait remains a
potent vehicle for expressing an artist's thoughts and feelings. A good deal of
Da-ka-xeen Mehner's art—photographs, sculptures, video—depicts himself.[2]
Mehner's self-portraits ensure artistic honesty and integrity. Among the Tlingit,
appropriating another clan's property, including its histories and stories, is
the height of disrespect. Thus, Mehner's insistence on his own voice is not
only a personal choice but also a cultural obligation. Through self-portraiture,
Mehner considers his complex and sometimes contradictory existence as a
man of Native and Euro-American ancestry, an artist and a worker, a Tlingit
contemplating his heritage. His artistic development, studied through the
lens of the self-portrait, advances from a desolation coupled with humor to an
equable maturity.

Mehner grew up commuting between the homes of his white
father and Tlingit mother. His non-conformist father was a professor at the
University of Alaska Fairbanks until he resigned in protest of the actions of
the university president. He then joined the Laborer's Hall Local 942 and
worked as a foreman building the Alaska pipeline. With the assistance of his

six-year-old son, the senior Mehner built a wood house with neither running water nor electricity in the forest near Fairbanks. Mehner's mother lived in Anchorage, the largest city in the state, but accompanied her extended family in subsistence activities such as berry picking and halibut and salmon fishing.

Mehner's artwork integrates the aesthetic and the manual. Living with his intellectual/laborer father, Mehner was intrigued by tools left around the house, learned their uses, and ultimately became a construction worker himself. He also sketched constantly and developed into an artist of considerable talent. The cerebral and the physical meld comfortably within this artist who uses building materials such as concrete and steel to produce masterful images and powerful sculptures that penetrate the senses and stimulate thought.

Cultivating his artistic side, nineteen-year-old Mehner enrolled at the Institute of American Indian Art (Santa Fe, NM) and later studied art at the University of New Mexico. Responding to the need for experimental and challenging artworks, he founded Site 21/21, a highly innovative contemporary art gallery in Albuquerque, where he served as director from 1994 until 2000. In 1998, Mehner also established the (Fort) 105 Art Studios in the same city. During the summers, he returned to Fairbanks to work construction and, in 2000, returned to Fairbanks to work full time.

This move proved most fortuitous. The University of Alaska Fairbanks has an active and successful Native Art Center, established in 1965 by Inupiat artist Ron Senungatuk. The program offers both a bachelor's and master's degree of fine arts degrees in Native arts. Numerous Alaska Native artists have studied or taught at the center, including Tanis S'eiltin (Eiteljorg Fellow, 2005) and Sonya Kelliher-Combs (Eitlejorg Fellow, 2007). Mehner enrolled in the program in 2004 and received his M.F.A. in 2007, the first Alaskan Native to earn this degree. After Senungak retired, Alutiiq Alvin Amason took over as head of the center. In 2009, when Amason resigned, Mehner applied for the directorship of the Native Arts Center and, happily, was appointed. Since then, he has not only thrived artistically, but he also has inspired and educated numerous students, many of them Alaskan Natives.

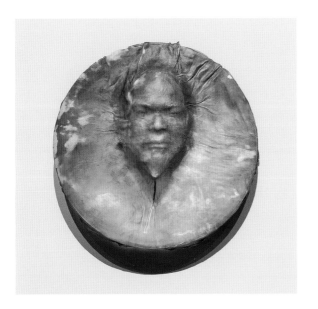

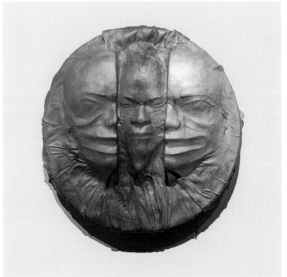

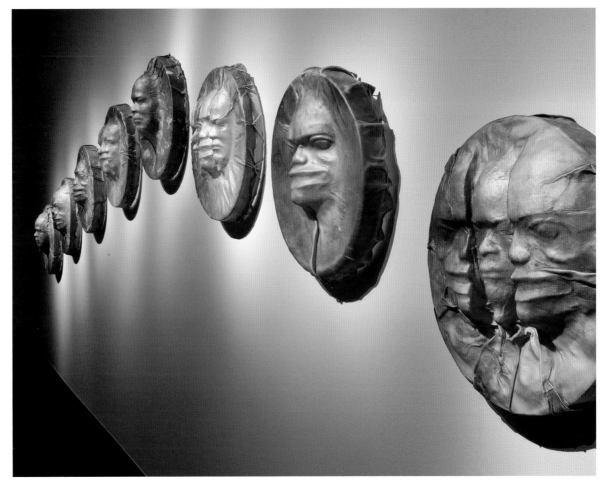

Above: *Saligaaw 1-9* (details) , 2014

Below: *Saligaaw 1-9*, 2014
Wood, rawhide

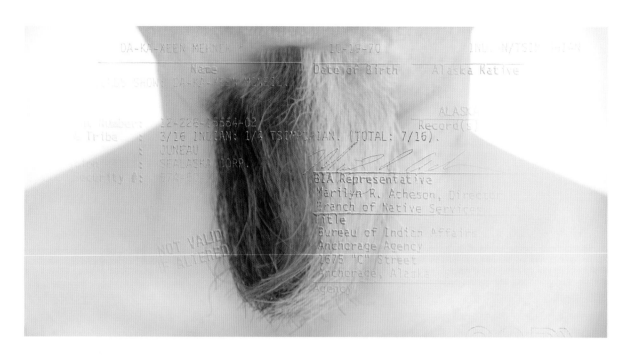

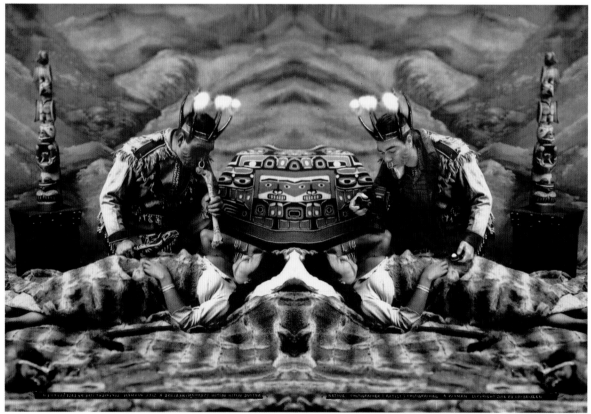

Above: *7/16ths*, 2005
Ink jet print

Below: *Native Photographer (Artist) Photographing a Woman*, 2007
Digital photo

Images courtesy of the artist

When Mehner was twenty, his uncle, photographer Larry McNeil (himself the recipient of an Eiteljorg Fellowship in 2007) gave him a 4 by 5 camera, and Mehner soon learned the delights of working in a darkroom, seeing images almost magically emerge. (Now using digital equipment, he regrets the loss of that inspiring darkroom experience.) The camera became a useful instrument of self-portraiture. A birthmark on Mehner's chin caused the left side of his beard to be white and the other side dark, a visual reference to his mixed blood. *7/16ths* (2005) is a striking self-portrait featuring Mehner's unusual beard behind the shadowy copy of his Bureau of Indian Affairs identity card. This card specifies the percentage of Native blood in Mehner (7/16ths). Because it is greater than 1/4, the U.S. government acknowledges that he is an American Indian and can thus call himself an "Indian Artist."[3] By juxtaposing his identity card onto his uniquely hybrid beard, this image emphatically criticizes the unyielding authority of the federal blood quantum policy.

In 2004, when looking through a collection of early twentieth-century photographs of the Tlingit, Mehner found several images dated 1906 depicting "Da-Yuc-Hene, the Thlingit Shaman." Because of this name, a phonetically spelled version of Da-ka-xeen, a name given only to his Dakla'weidi clan members, Mehner recognized his close kinship with this man. Posed in the Juneau studio of Case and Draper against a backdrop painted with a landscape and surrounded by model totem poles, textiles, and clan regalia, Da-Yuc-Hene appears in several guises — as a seated chief wearing a Chilkat robe and basketry hat, as a seated shaman, and as a shaman curing a sick woman. Mehner transformed those images into a series of new photographs by inserting himself as a mirror image of his relative, wearing the same clothing and face painting and posed almost identically. Interweaving the colonialist images of his ancestor with his own reflected image, he created a diptych, *Native Photographer (Artist) Photographing a Woman* (2007). The two halves of this image—seemingly identical but different in details—quote the subtle variations between halves of bilaterally symmetrical Tlingit two-dimensional art.

Du-Yuc-Hene and Da-ka-xeen differ by carrying their unique technologies of magic. The shaman holds a carved bone illustrating spirits that assist him during his healing trances and shakes a rattle (wrongly held right-side up, by the way) to summon those spirits. With his right hand, Mehner

focuses a camera on the face of the sick woman, and with his left, he holds a light meter. Each man's implements of transformation change the woman's state, either from sick to well or from person into artwork. The combined photograph also transforms the colonized into the sovereign.

The original photograph includes many stereotypes of the Native studio shot. Dressed up in shamanic regalia no longer used, exoticized as a "witch doctor," Da-Yuc-Hene the man diminishes into an object of the photographer's intentions. By his self-representation as a photographer who manipulated the original, Da-ka-xeen asserts himself as subject. While doing so, he brings Da-Yuc-Hene away from the objectified and stereotyped Indian of Case and Draper, bonds with him in a mirror image, and escorts his relative away from his disempowered depiction. Serious as this message is, the surprise appearance of the artist in Native regalia juxtaposed with his namesake generates a smile—an occurrence not rare in contemporary Native art.[4]

With materials he used as a construction worker, Mehner also creates powerful three-dimensional works through which he investigates his identity. He favors the rough surface and physical presence of industrial materials such as concrete and steel. In *My Transformation* (2007), an over-life–size concrete torso cut off at chest height supports a mask-like face, vaguely reminiscent of Northwest Coast sculpture, with full lips and penetrating yet vacant eyes. Much like the Kwakwaka'wakw transformation masks from coastal British Columbia, that face can be split in half to reveal a concrete life cast of Mehner's face that appears to float within.[5] This self-portrait in the rough textured, mottled medium of gray concrete is an exact replication that, with its impassive and immobile expression, appears almost lifeless. Ironically, the surface energy generated by the pockmarked and variegated concrete adds dynamism to the sculpture.

What is the artist's relationship to the mask concealing and revealing his face during, according to the work's title, *My Transformation*? Does the open mask present a face that is Native or non-Native? Does it close to shut out the Native or non-Native man? Or is this a self-portrait of the artist, his heritage irrelevant, who, by physically existing within the artwork, asserts his individuality and creativity while hiding within, remaining incommunicado and

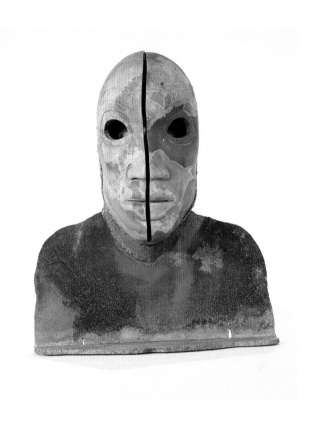

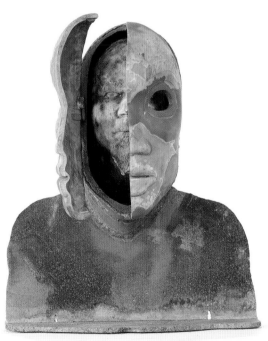
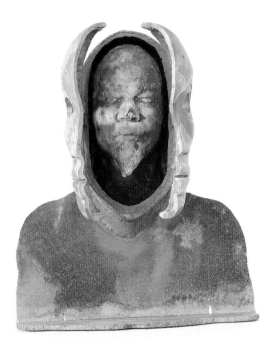

Weapons of Mass Defense, My Transformation, closed and open, 2007
Concrete, steel, bronze
Images courtesy of the artist

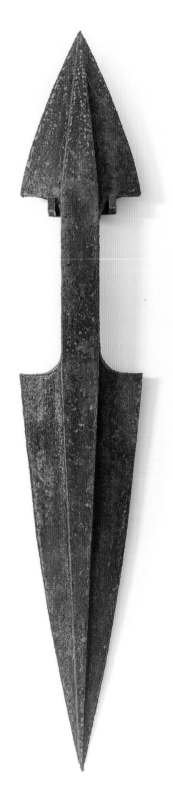

Weapons of Mass Defense I, 2007
Steel
Image courtesy of the artist

unknowable. Like the transformational mask used in ceremonies, this concrete replica moves perpetually between the artist's different inner selves. Mehner's inscrutable face seems perpetually paralyzed within the mask, whether it is closed or opened, perhaps unable to resolve these questions.

One of Mehner's favored objects is the Tlingit dagger, a weapon of war once carried by every Tlingit male. The oldest type, made first of copper and then of iron, is doubled-bladed, with a pommel that is shorter than but as sharp as the main blade. Hide lashing covers the hilt and forms a handhold.[6] After firearms rendered them obsolete, the Tlingit continued producing daggers as cherished heirlooms throughout the nineteenth century. Mehner crafts metal daggers for his family (he sells neither the functional knives nor the carved masks he makes, giving them instead to family members who in the past had no such Tlingit objects) and manufactures oversize daggers from construction material as sellable artworks.

Mehner's daggers embody the history of Tlingit colonialism. In precontact times, neighboring groups feared the warlike Tlingit. When the Russians arrived in southeast Alaska in the late eighteenth century, they too found the Tlingit formidable opponents, and throughout their occupation, they failed to control them. Only after large numbers of American settlers arrived in the late nineteenth century did the Tlingit experience the subjugation and intolerance encountered by Indigenous people worldwide. They nonetheless never ceased being warriors and throughout the twentieth century fought against discrimination and for education and their land, ultimately winning those battles. Mehner's sharp, assertive daggers become portraits of contemporary Tlingit sovereignty, wealth, and cultural strength.[7]

Alaska Native land claims were settled in 1971, ironically as a result of the decision to build the trans-Alaska pipeline. In response to an invitation to participate in *Dry Ice*, an exhibition of Alaskan Native landscapes, Mehner focused on the pipeline, which carries oil pumped on the North Slope in the arctic to the port of Valdez, hundreds of miles to the south.[8] Before the pipeline was constructed, Native land claims contested some territories through which the pipeline was to pass. To avoid endless legal disputes that would have delayed building the pipeline, in 1971 the United States Congress passed the

Alaska Native Claims Settlement Act (ANCSA) that purchased from Alaska Natives the rights to certain lands and established processes to identify which other lands would be Native-owned. The billions of dollars allocated for this purchase were distributed among village and regional corporations that invested the funds and distributed earnings to the Native shareholders. This created some of the richest businesses in the state, including the Sealaska Corporation, which covers southeast Alaska.

The pipeline signifies many things to Mehner in addition to its role in Alaska Native history. Mehner's father worked in the Alaska oil operation on the North Slope, and thus the pipeline was a source of family income. In addition, it provides for Mehner and his family numerous recreational opportunities such as snow machining in the winter, and, in the summer, blueberry picking. The pipeline also parallels the road Mehner takes to go salmon fishing on the Chitina River. In *My Right-of-Way Summer* (2009), a dirt road through spruce-covered hills could be a wilderness trail but is in fact the pipeline right-of-way. This landscape is superimposed over a mirror image of circles—actually 55 gallon drums lying on top of one another and filled with automobile parts and other industrial detritus—and bowls of the blueberries that grow in abundance on this open space. Challenging the stereotype of Alaska as an untouched wilderness, for Mehner, the pipeline landscape embodies subsistence for his family as well as Native control over their lands. The pipeline is not a scar on the landscape but a vehicle for transportation and food. It's an integral part of life up here—invisible yet prominent. It's part of an important economic and social landscape.[9]

Mehner's more recent works represent a subtle change in focus, an attention less to his personal identity and more to a deepening relationship to his Native culture. For example, *Language Daggers* addresses the devastating loss of the Tlingit language at the hands of teachers and missionaries. Daggers of uneven height stand in a circle facing each other, posed as if interacting, some barely visible blade points, others full blades and hilts, and one complete dagger standing opposite the shortest pieces. The blades on one side emerge pommel first, as if the knives are being thrust into the floor; on the other side, the blades appear first, as if the daggers are rising through the floor from below.

My-Right-of-Way Summer, 2009
Digital print
Image courtesy of the artist

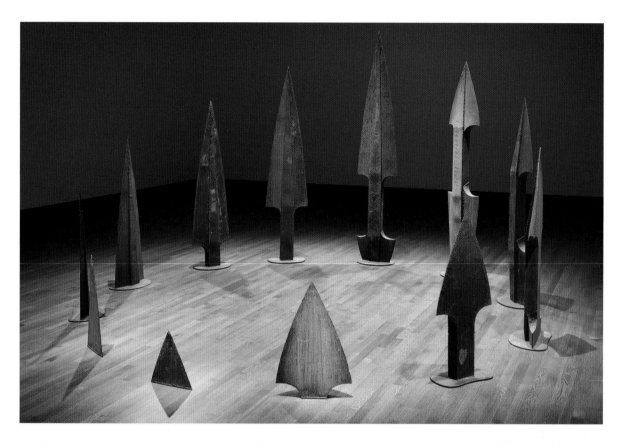

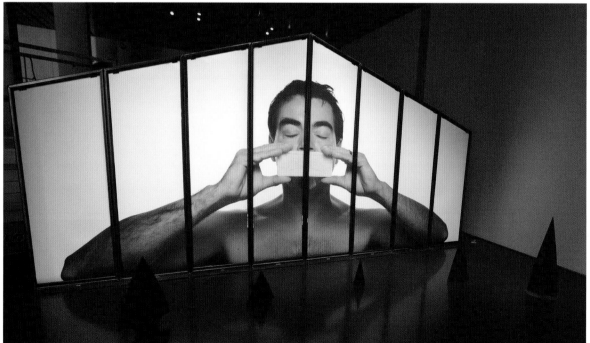

Above: *Language Daggers*, 2012
Steel

Below: *Finding My Song*, 2011
Various materials
Image courtesy of the artist

This installation addresses the importance of language to the Tlingit. The knives on one side contain text: simple, everyday Tlingit words like "thank you," "hello," and "I love you." On those opposite are the same words in English. When these daggers were exhibited as part of the 2014 *Finding My Song* exhibition at the Anchorage Museum of History and Art, near the circle was a photograph of a bare-chested Mehner holding under his nose a large bar of Fels Naphtha soap. The frame for this image was shaped like the pitched roof communal house in which forty to fifty related Tlingit used to live, alluding to a time before missionaries and others who insisted they live in single-family homes. This was also before the boarding schools in which teachers washed out the mouths of students speaking their language with soap, forcing them to learn English. Mehner's grandmother would pass Fels Naphtha soap at the store and say, "I can still taste that soap in my mouth," remembering the mean-spirited teachers who punished her for speaking Tlingit. At a Tlingit potlatch, the ancestors are honored and their stories told. Here, Mehner is seen breathing in deeply the fragrance of this hated soap and recalling his own ancestor's trials and those of their people, while at the same time honoring their memory with the endurance of language recorded upon the daggers. These powerful metal forms demonstrate the near-disappearance of Tlingit—as the daggers grow increasingly shorter—and the imposition of English—as those daggers become longer.

Contained within the assemblage of sculptures are signs of a positive future. That the shortest dagger is not completely hidden suggests that all is not fully destroyed, for programs have developed in Tlingit communities to teach youth their ancestral language. The implement of power and dominance, the upright, complete dagger, stands tall and imposing like the Tlingit of today, who with their wealth, their political power, and their cultural pride are a force to be reckoned with. One significant indicator of that cultural pride is the flourishing of dance performances throughout southeast Alaska. The *Language Daggers* rhythmically circulate up and down, evoking Tlingit male dancers who energetically alternate between erect and crouching positions, at the end standing erect and proud.

A spectacular three-day event named "Celebration" takes place every other year in Juneau. Dozens of southeast Alaska dance groups, as

well as groups from British Columbia, Washington and even farther afield, perform songs and dances to a largely Native audience of hundreds.[10] In 2010, Mehner's eighteen-month-old son Keet joined him at "Celebration" and discovered the delights of dancing and drumming. When they returned to Fairbanks, Keet got his own drum, which he used so incessantly that he wore it through and it had to be reskinned. As for Mehner, the endurance of song, the enthusiasm of dancers, the vitality of culture, the creativity revealed by the abundant regalia, musical instruments, and varied dance props became an inspiration. So he began to make his own drums.

As one might expect, these percussive instruments are not the conventional Tlingit drums meant to be beaten and bearing the crest of the clan who owns them. As in so much else of his artwork, Mehner combines the traditional, in this case the technique of drum-making, with the singular, here an original presentation of his face. After soaking elk hide for a day, he stretches it over a plaster cast of his face.[11] Atop the hide he places another, negative mold of his face and lets it all rest for two days. After "the magic moment…when you separate it all," Mehner's faces on these drums are more animate than his earlier self-portraits. His face pushes forward, straining the constraints of the flat drum surface, the hide wrinkled and creased. No longer the passive man of concrete, frozen by his question of "who am I," Mehner now actively asserts himself as an individual comfortably situated in the complex postcolonial world.

A central element of Tlingit society is balance and respect between two moieties, the Ravens and Eagle/Wolves. In the past, one could only marry someone of the opposite moiety. Even at present-day memorials honoring the deceased, the host clan feasts members of the opposite moiety and presents to them their treasured clan crests. By accepting payment from their hosts, these guests validate their opposite's treasures.[12] In *Call and Respond 1 & 2*, two sets of drums on opposite sides of the room face each other in dialogic interaction and interpret these reciprocal relationships in a unique fashion. Since Mehner can only present himself as a Dakla'weidi clan member and can never speak for anyone from any other clan, much less someone on the other side, he simply alludes to this fundamental reciprocity by the opposing drums.

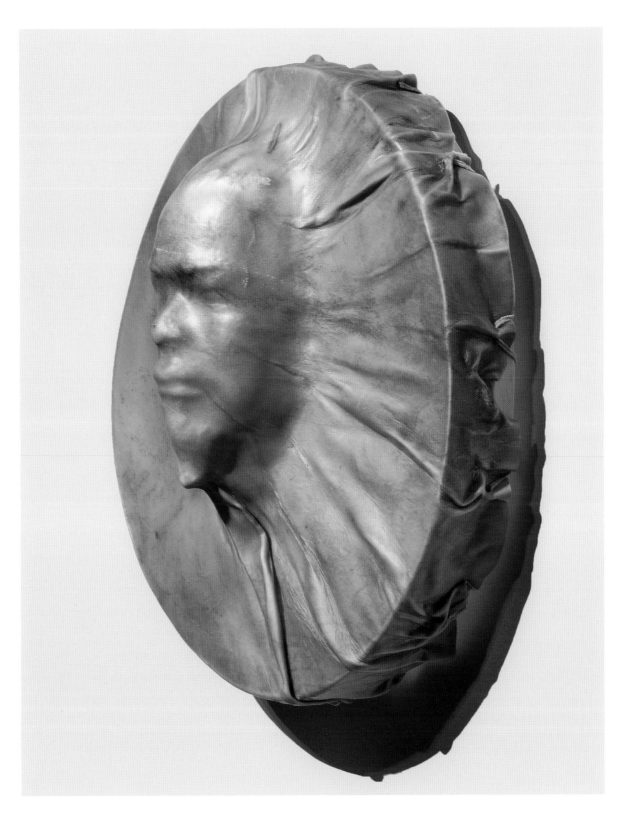

Gaaw Kootéeyaa 1, 2, 3 (detail), 2014
Wood, rawhide

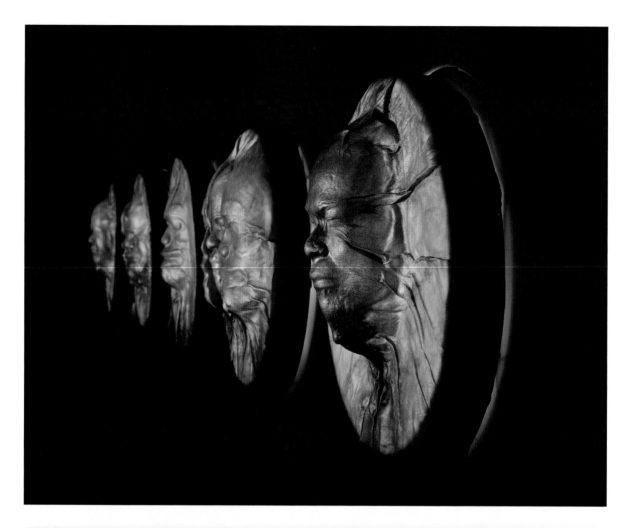

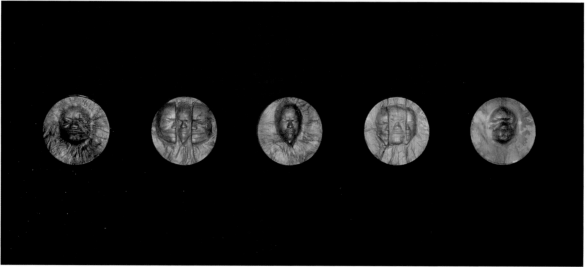

Above: *Call and Respond 1*, 2014
Wood, rawhide with video projection

Below: *Call and Respond 2*, 2014
Wood, rawhide with video projection

In *Call and Respond 1 & 2*, Mehner returns to the earlier concept of a transformation mask. At each end of the line is the artist's face, next to it a half open transformation mask partially revealing his face, and in the middle, a fully closed mask hiding it. Initially, these drums are in shadows, with no illumination. Then, on one side, a video of the ocean appears over the left drum. Slowly, the video shines on the middle, and then on the right-hand faces. This video displays a split screen image of symmetrical waves rushing out and in. When the movement is out from the middle, it appears almost as if the middle face is giving birth to energy. Then on the reverse, it sucks it into itself. The dramatic images imbue the installation with dynamism, enhancing Mehner's actual singing in the video.

Then the video stops playing, and the drums become dark. Soon a projection of Mehner's face appears on the central drum, and he begins to sing. This song belongs not to him as an individual, but as a member of a clan. Although Mehner may find it highly unlikely that he will ever become fluent in Tlingit, he can learn those communal songs that are central to the identity of his whole clan. More importantly, he can teach them to his son. After this song, darkness again hides the drums. Then the faces on the opposite side begin flickering rapidly with videos of flying over snow-capped mountains. When this mesmerizing video stops, multiple images of blurred faces (all Mehner's) project onto the outside drums while several recordings of Mehner's voice sing the Canoe Song in unison. The Canoe Song narrates the clan's descent from the mountains—projected onto one set of drums—to settle by the sea that appeared on the opposite drums.

In the summer of 2014, the Museum of Contemporary Native Art in Santa Fe installed *Saligaaw (Speaking in a Loud Voice)*, which continues Mehner's examination and presentation of preservation of and reconnection with Native language. Multiple drums with Mehner's face on them hang on two walls, one group lined up in an inverted "V" and the others stacked vertically into three clusters of three. Both groupings allude to Mehner's heritage by delineating the shape of an old Tlingit house roof and suggesting three carved house posts lined up in a row.[13] These references extend beyond structural and sculptural forms and penetrate to the heart of Tlingit society. In the clan house lived large groups of related people; the house posts within depicted

episodes from their ancestors' history. Although Mehner's is the only face on these drums, their placements upon the walls imply the group—his family, his ancestors, and by extension, all his people. The loud voice is not Mehner's alone—it emanates from the many who share his objective to reclaim his culture in a manner befitting the twenty-first century.

Da-ka-xeen Mehner initially used the self-portrait to scrutinize his own identity. He still makes self-portraits, but with softer material rendered more vigorous with songs, photographs, and videos. Once the concrete faces and steel daggers seemed to be isolated components within art exhibitions; now, in installations such as *Call and Respond 1 & 2* and *Language Daggers*, elements interact. Earlier, he presented himself as an individual in isolation; now he embraces the many. This art reveals the maturity and confidence of a man no longer struggling with questions of identity but instead comfortably inserting his highly original and intellectually stimulating art into the domain of Tlingit cultural heritage.

On the Northwest Coast, art still plays a significant role in ceremonialism. Leaders present clan regalia such as crest hats, treasured daggers, and old Chilkat robes at Tlingit potlatches. Young dancers perform in recently carved masks and wear newly made regalia. Such carvings, paintings and textiles that adhere to a nineteenth-century canon are enthusiastically utilized by performers and purchased by discriminating consumers. Most Northwest Coast artists who experiment with new visual expressions have had to acknowledge the strength of these visual conventions and work with, around, or over them. Some incorporate form-lines and other elements of two-dimensional style while remaining highly inventive.[14] Others, like Mehner, look elsewhere for inspiration.[15] He utilizes historic objects—daggers and drums—as well as non-visual traditions—songs, words, and stories—in his artistic endeavors. As Mehner effortlessly integrates elements of Tlingit culture, past and present, with his consistently innovative and unorthodox creativity, he produces artworks that are both intensely personal and attuned to the community of his ancestors.

Over the last decade, my art has changed as I have changed. More contemplative today, less yelling, speaking more evenly.[16]

Following pages: *Language Daggers*, 2012
Steel

[1] I would like to thank Da-ka-xeen Mehner for his time and patience with my questions, and Maya Salganek for reading over the manuscript and providing valuable information.

[2] For more on Native self-portraits, see *About Face: Self Portraits by Native American, First Nation, and Inuit Artists*, eds. Z . Pearlstone and A. J. Ryan (Santa Fe: Wheelwright Museum, 2006), for an extensive investigation into the variety of these images. Also, Rosalie Favell (Métis) has been using portraits to explore identity. See http://www.santafenewmexican.com/pasatiempo/art/gallery_openings/eye-to-eye-rosalie-favell-s-portraits-of-native-artists/article_543bbb52-c3dd-11e2-8345-001a4bcf6878.html.

[3] This rule has now changed to allow tribal enrollment and heritage to determine the designation of "Indian artist."

[4] The best-known examination of this is Allan Ryan's *The Trickster Shift* (Vancouver: University of British Columbia Press, 1999).

[5] Interestingly, Mehner learned the process of life casting when, at IAIA, he was introduced to a group who cast faces of famous people for use by the blind.

[6] For a thorough discussion of these weapons, see Ashley Verplank McClelland, "The Evolution of Tlingit Daggers," in *Sharing Our Knowledge: The Tlingit and their Neighbors*, ed. Sergei Kan (Lincoln: University of Nebraska Press, 2015), 394–416.

[7] But sometimes Mehner adds other dimensions to his daggers with references to modern-day wars that devastate both civilians and soldiers. In fact, this stark angular steel form embraces both the endurance of an aboriginal group and contemporary destruction of life. See Aldona Jonaitis, "A Generation of Innovators in Southeast Alaska: Nicholas Galanin, Stephen Jackson, Da-ka-xeen Mehner and Donald Varnell," *American Indian Art Magazine* (Autumn 2008), 54.

[8] *Dry Ice: Alaska Native Artists and the Landscape*, curator Julie Decker. Catalog of exhibition at the Princeton Arts Council Paul Robeson Center for the Arts, 2006. See http://da-ka-xeen.com, under "Articles." Accessed 4/22/15.

[9] Conversation with author, 1/13/15.

[10] See *Celebration 2000: Restoring Balance Through Culture*, eds. Susie Fair and Rosita Worl (Juneau: Sealaska Heritage Foundation, 2000).

[11] Mehner is indebted to Sonny Assu, with whom he has a Facebook relationship, who told him of the excellent qualities of elk skin for this purpose.

[12] As might be expected, it is far more complex than this. See, for example, Sergei Kan, *Symbolic Immortality: The Tlingit Potlatch of the Nineteenth Century* (Washington, DC: Smithsonian Institution Press, 1989).

[13] Tlingit interior houseposts are more ancient in the region than totem poles.

[14] For Northwest Coast artists who use these visual traditions in innovative ways and for various purposes, see, for example, Dana Claxton, "Lawrence Paul Yuxweluptun: Master Mixer, Man of Many Colors," *Red: Eiteljorg Contemporary Art Fellowship 2013* (Indianapolis: Eiteljorg Museum, 2013), 21–43; and Andrea Walsh, "Marianne Nicholson Kwakwaka'wakw," *Contemporary Masters: the Eiteljorg Fellowship for Native American Fine Art* (Indianapolis: Eiteljorg Museum, 1999).

[15] For artists who diverge from the canon, see, Veronica Passalacqua, "Tanis Maria S'eiltin: Coming Full Circle," *Into the Fray: The Eiteljorg Fellowship for Native American Fine Art 2005* (Indianapolis: Eiteljorg Museum, 2005), 97–110; Mique'l Icesis Askren, "Larry Tee Harbor Jackson McNeil: Visual Myth Maker," *Diversity and Dialogue: the Eiteljorg Fellowship for Native American Fine Art* (Indianapolis: Eiteljorg Museum, 2007), 77–94; and Tania Willard, "Nicholas Galanin: Translate Transpose Transmit. Shifting Indigenous Aesthetics," *Red: Eiteljorg Contemporary Art Fellowship 2013*, 65–80.

[16] Conversation with author 1/13/15.

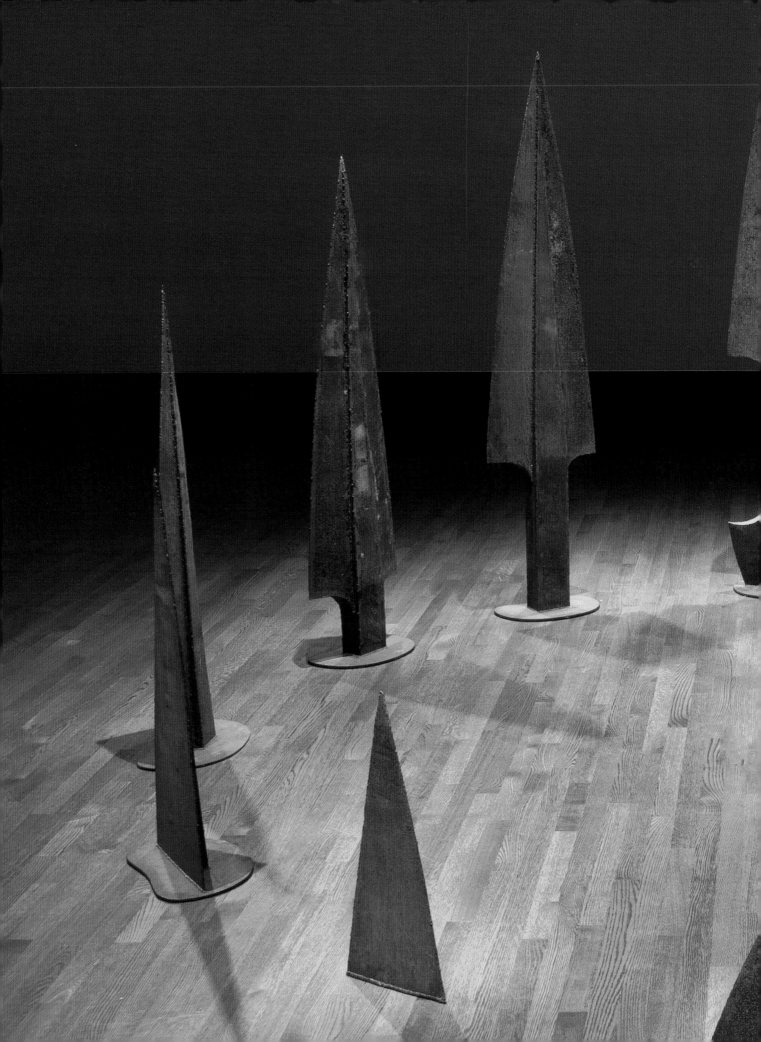

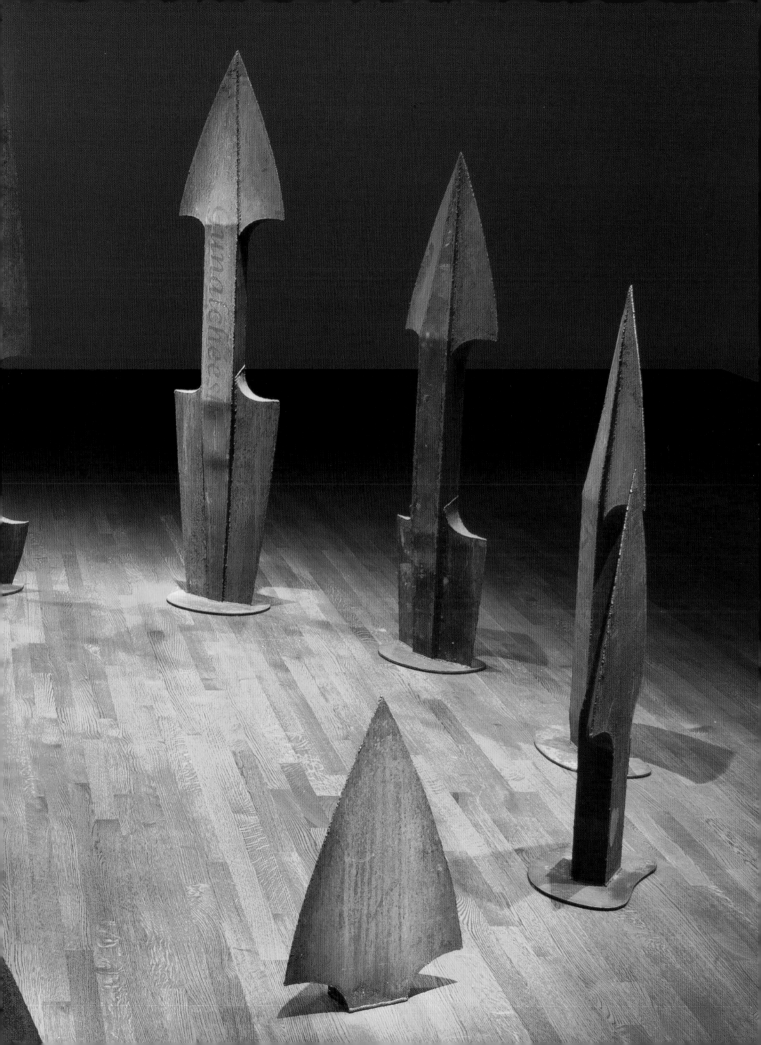

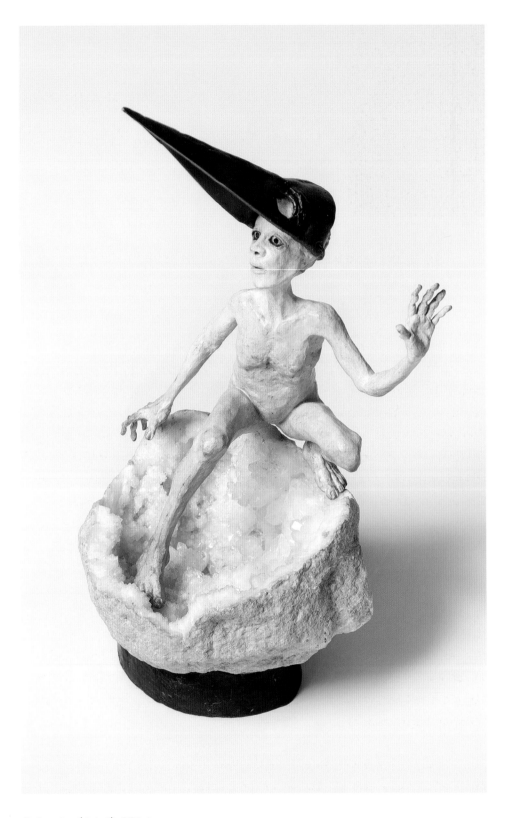

Belonging (detail), 2014
Bronze and geode

Holly Wilson (Delaware Tribe of Western Oklahoma/Cherokee): Bronze Stories

By Margaret Archuleta (Tewa/Hispanic)

My figures serve as storytellers, stories of the sacred and the precious, capturing moments of our day, our vulnerabilities, and our strengths.
 —Holly Wilson

Holly Wilson's bronze figures are powerful portraitures of human emotion and reactions. The little figures are visual narratives of a moment captured in time. The figures, only four to six inches in height, require the viewer look closely at them to appreciate their extraordinary facial expressions. Upon close inspection, they share an intimate moment with the viewer. Wilson's ability to capture otherwise forgettable moments is due to her observational skills, her aesthetic, and her talent. Each figure is a tiny individual treasure of emotion. Through their placement, gestures, and intimate size, Wilson's "little people" visually communicate with the viewer. The figures' storytelling qualities are shaped by Wilson's uncanny ability to see the unseen—a dragon in a stick—or to capture the transformation of a familiar and otherwise commonplace event into a moment of wonderment and amazement. Her adeptness as an observer distinguishes her art. She translates her observations into visual narratives, turning to her Indigenous roots through her storytelling. "I grew up hearing many stories from my mother . . . Then I had my son and daughter and now those stories have taken on a whole new meaning. I tell stories of my own family intertwined with that of my past and with the past of my mother's family."[1]

Wilson's bronze figures are enlivened through her keen sense of imagination and power of observation. Her ability to capture the familiar and

ordinary moments of everyday life distinguishes her art. ". . . the way a certain stick looks like a bird in flight, or the amazement of [my] son when he saw the inside of a geode rock for the first time. These moments begin to intersect, and the work grows from the many elements seen, found, remembered, or felt."[2]

Wilson works in bronze using the ancient lost wax technique, one of the oldest metallurgical processes, to create her intimate sculptures. Her casting process is labor intensive because each of her sculptures is unique and individual—no molds, no large editions, only a one-of-a-kind sculpture. Conventionally, sculpture, especially bronze, has been seen as a male-dominated art form, and Western art has historically perceived bronze sculpture as having a higher value than other mediums. The ability to manufacture monumental sculpture through the use of molds, the ease in creating precise details through the use of wax, and the durability of bronze may contribute to bronze's elevated value as an art form. The construction of bronze sculpture often is a creative collaboration between the artist and a specialized foundry of highly skilled ". . . mold makers, casters, chasers, and *patineurs*–who jointly made decisions regarding surface, color, texture, scale, and form."[3]

Wilson works alone, without a foundry, and she fabricates her small bronze sculptures in her studio in Mustang, Oklahoma. She has assembled unconventional "art" materials such as roof flashing from Home Depot, duct tape and bailing wire from hardware stores, and pizza pans from her kitchen to supply her custom-built bronze studio. She also uses a ceramic kiln, a propane tank, and a shop vac in creating her sculptures.

> *My casting process is a little different [than most]. I use investment slurry instead of ceramic shell . . . similar to jewelry casting. . . . In my casting process I make an original piece of work directly in the wax, there is no mold [emphasis added]. . . . I studied ceramics . . . [as] an undergraduate, and . . . I was used to building things [in] clay. . . . [Now] I use the wax freely like I did the clay. Once the piece is made in wax, I use wax sprues to create channels that will allow the metal to flow after burning out when I cast. . . .*

I create cylinders from flashing I get at Home Depot [,]. . . . [I] use duct tape to seal [the cylinder] and [wrap] bailing wire [over the duct tape] to hold it during the firing when the tape . . . burn[s] off.

I use oil-wax clay to make [the] sealing ring and then I attach the sealing ring [onto] a pizza pan. I pour hot wax about a quarter of an inch [into] the bottom [of the cylinder] . . . with my sculpture...[when the] wax . . . cool[s,] I mix my investment and pour that around the sculpture in the cylinder. [After letting it set] for two hours . . . [I] remove the sealing wax and then place [it] into a ceramic kiln for burn out.

The sculpture cylinder is placed with the opening facing the bottom so that the wax can burn out. This . . . process [takes] 21 hours . . . [T]his create[s] a hollow shell which I will then pour the hot metal into. [During the last] hour or so of [the] burn out process I assemble the crucible and the furnace and began heating and melting the metal.

For [the] melting [process] I use a furnace I made myself . . . It has a propane tank for the gas and I use a shop vac to create forced air to get the temperature I need which is around 1590 to 1790.

Once [the] metal [reaches the proper] temperature, I turn off the kiln and pull the cylinders out and place [them in a sand pit with the opening facing up. Using my crucible tongs I pour the hot bronze into [the opening of] each . . . different cylinders . . . [creating] the positive bronze sculpture.

I do one final sandblasting and then I cleaning off the surface and began the patina process. Patina is a chemical material that attaches to the metal; some etch it like an acid to give it color. [My final step is to] . . . seal [the sculpture] with wax. . . .[4]

Fine Art Today's contributing editor Jeffrey Carlson described Wilson's work as "anything but derivative. . . . For Wilson, the medium in which she casts her figures conveys a sense of their significance. Casting in bronze allows Wilson the opportunity to implicitly assign great value to the subjects she addresses, which include life, relationships, and emotional states."[5]

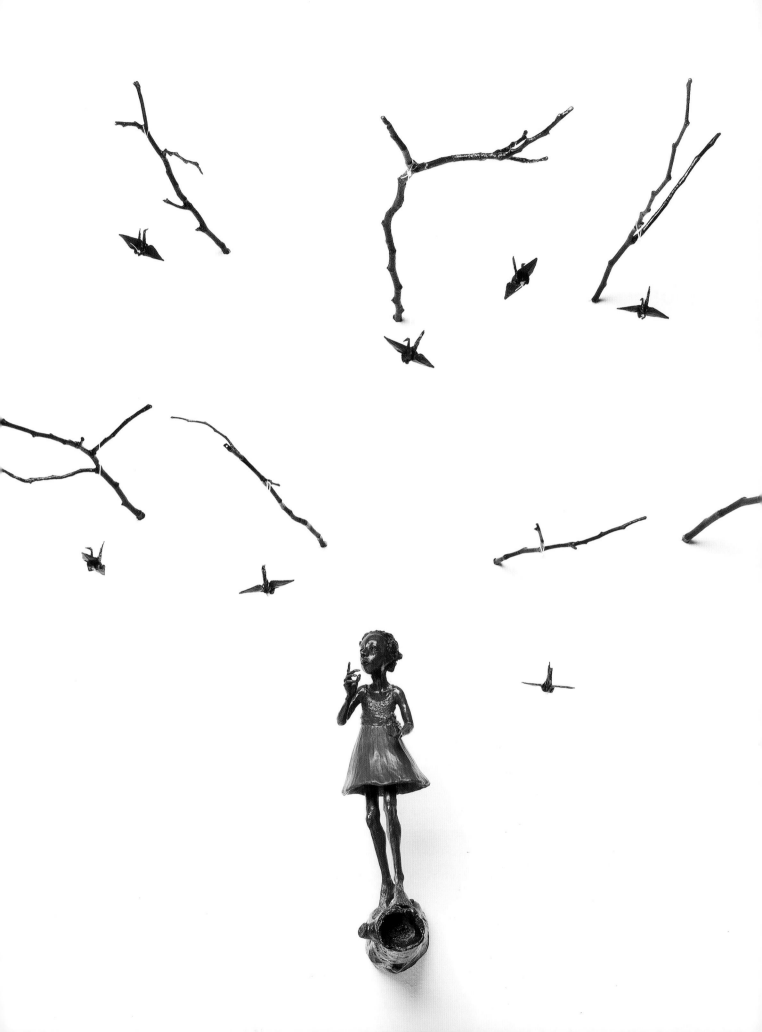

Wilson often refers to her figures as storytellers. Her artwork is inspired by stories from her Delaware and Cherokee heritage and by everyday life. "My figures serve as storytellers, stories of the sacred and the precious, capturing moments of our day, our vulnerabilities, and our strengths."[6] In addition, Wilson's own son and daughter have directly inspired her use of children as a subject for her bronzes. "These little figures are pulled from the daily observation of my own children. Watching them face the challenges of life…how my children were seeing things and experiencing things."[7]

Little bronze girls in bright red dresses tiptoe along wooden sticks, poising themselves on wooden ledges—suspended—for a moment. The positioning of the tiny bodies, with their hands raised in hesitation and quizzical expressions on their faces, captures the viewer's attention and brings a sense of uneasiness to the vignette. Other figures playfully crouch on the edge of a geode that has been broken in half. The figure's face is hidden behind an elongated bird-like mask. "I want to sculpt emotions, emotions that you can put on like a skin and breathe in—a moment frozen in time. I want you to feel another's life, for just that moment to see we are all one below that surface, that surface of skin—no matter the color, the shape, or origin."[8]

Over the years, Wilson has developed iconic images, aesthetic clues that strengthen the storytelling qualities of her artwork. Children—especially her own—are Wilson's primary iconic subject. With only rare exceptions, her bronze figures do not wear clothing and do not have genitalia. They play with the insouciance of childhood. They are not constrained by clothing or by notions of gender. The only clothes that her girls wear are red sundresses. "The red dresses are from my youth. My mother made most of our clothes and there was a red sundress with Raggedy Ann dolls on it I loved. I think of that dress and how I grew up, both little girl in dresses and wild child running through the creeks collecting horny toads in the field behind the house."[9] The dresses are sometimes plain or with appliquéd flowers around the hem, but always red. "Red has always been my favorite color, it makes me think of so many emotions, passion, anger, love. I think of a heartbeat and the blood in our bodies and that connection to another through that bloodline."[10] Wilson

Opposite: *Secrets are Burdens*, 2014
Bronze, flex cord

uses birds as metaphors for burdens—'birdens'—as secrets, as messengers, and as observers. She depicts origami birds, bird masks with elongated beaks, birds on branches, and birds in the process of transformation. Masks are used throughout Wilson's art. Masks, real or imagined, are layered with meaning. They can be used to disguise, to transform, to imagine, and to create. "[Masks] . . . become an identity that one can live through or hide behind in our roles—I am a daughter, a sister, a friend, an aunt, a wife, a mother, [an] artist, and [an] Indian."[11]

Rider is the visualization of a story Wilson made up with her daughter about a girl who finds a beautiful dragon with a long body and tail that only she can see, much to the amazement of the dragon and the girl. Her ability to see the dragon signifies that she is a Dragon Rider. Rider is a small masked figure, crouching to balance herself on a stick. She holds onto the stick with one hand while waving the other hand in the air, reminiscent of a rodeo rider. The sculpture is suspended from the gallery wall and consequently casts a shadow. Wilson utilizes the negative space of the shadow to emphasize the sculpture's reflection and transform the stick into a dragon and the figure into a Dragon Rider. The placement of the bronze figure toward the front end of the stick highlights its curve, and its unevenness reflects the silhouette of a dragon on the wall. The figure appears to be sitting behind the dragon's ears and holding onto its scales as they ride through the sky together.

The figure wears Wilson's iconic elongated bird-beak mask. The mask is not used as a disguise, but rather as a symbol of power. Magically, the mask becomes the headgear worn by the Dragon Rider, emblematic of the rider's power to tame the dragon. The rider is a metaphor for flying and for the unbridled feeling of freedom and joy. Rider invites viewers to re-experience the joy of childhood.

Belonging illustrates the time when Wilson's son found a geode on her family's trust land in Oklahoma. The mystery of the geode, the crystals inside, is discovered only when the rock is broken in half. Belonging, through the geode, becomes a vehicle for Wilson to explore issues of duality. Curiosity and amazement are depicted in the positioning and gestures of

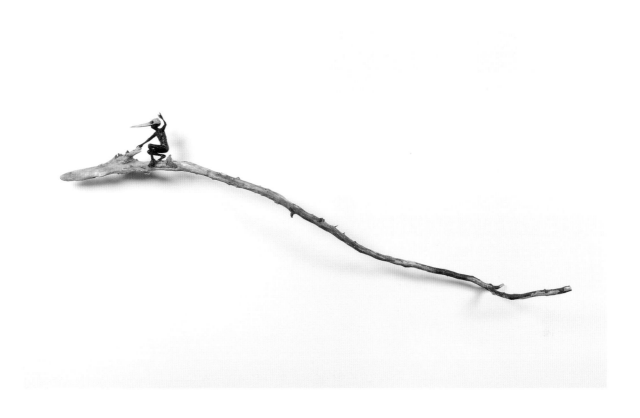

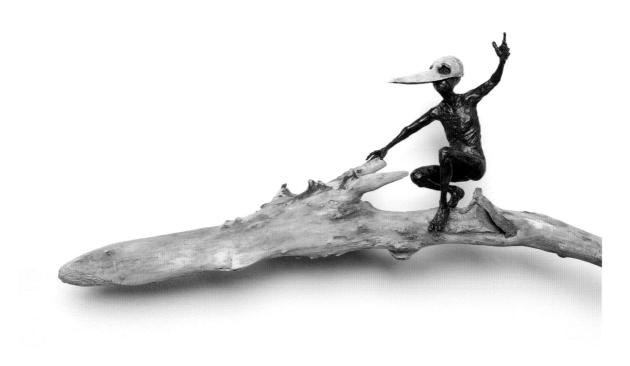

Above: *Rider*, 2014
Bronze, patina and wood

Below: *Rider* (detail), 2014

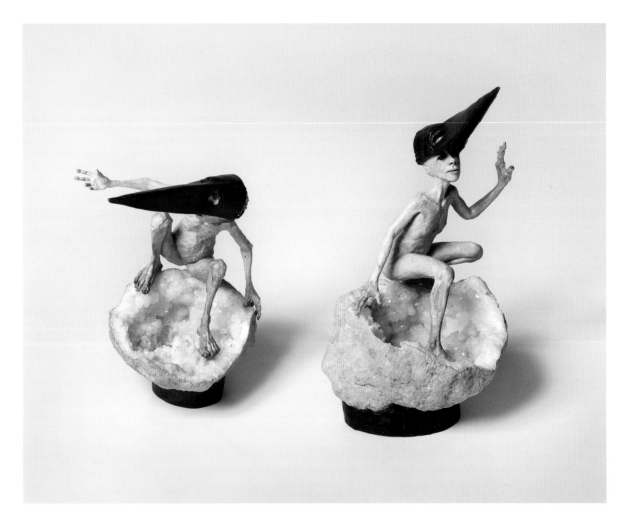

Belonging, 2014
Bronze and geode

two crouching bronze figures as they balance on the edges of a broken geode, one on each half. The figures are not wearing any clothing, revealing that they are without any references to the biological characteristics that define female and male. According to Wilson, they represent a girl and a boy. They carefully balance on the broken halves of the geode, symbolically representing the duality of the female and male essence in each of us and the balance we strive to maintain. Together, the figures represent the whole, each half belonging to the other and, without one another, being incomplete. The process of "keying" the figures to their base technically resolves the uncertainty of their positioning on the edges of each geode half. The figures were fitted, not glued, into the geode during the wax stage of manufacturing. The figures are not additions to the geode, but a part of it.

The geode also represents the land—trust land—plain and seemingly void of value until it is broken open to reveal the precious crystals. In the early reservation period, Indian trust land was often considered useless for farming. It was not until oil and minerals were found on Indian land that it became "valuable." The geode, plain on the outside, hides its precious internal crystals. Metaphorically, the geode is the land; the land is the people; and the people belong to the land.

Each of the figures in *Belonging* wears Wilson's characteristic elongated black patina bird-beak masks. The masks do not completely cover their faces, allowing the viewer to see the amazement and wonder that animate their faces and their postures. The male figure[12] motions the viewer to look at his discovery. His outstretched hand beckons the viewer. His left foot rests inside the geode and his right foot and left hand anchor him to the edge of the rock. The female figure's mask slips off her face to reveal her wide-eyed wonder when she looks up from the mysterious rock. Her excitement is additionally expressed in the gesture of her open left hand.

In *Secrets are Burdens*, a barefoot girl with short curly hair, wearing a red dress, walks to the end of a bronze branch mounted to the gallery wall. She gazes at the viewer as she raises her right index finger to her lips in a gesture of silence or caution. In Wilson's artwork, secrets are burdens—

the act of keeping a promise, of responsibility, and memories. Hanging from stick-branches made of bronze are tiny paper cranes made of bronze and finished in black patina. The individual cranes and stick-branches are mounted to the wall. This technique of mounting the artwork allows Wilson to use the negative space of light and shadow. The spotlight rakes across the artwork from above, creating delicate shadows across the gallery wall. "When light falls on the figures, the shadow cast on the wall represents, for me, a memory . . . Like a shadow, these memories cannot be held."[13]

For Wilson, these tiny bronze cranes represent secrets, little burdens that one must keep whether the secret is good or bad. The keeping of secrets requires a sense of responsibility, a solemn oath. "Secrets . . . whispered in the schoolyard from one child to another and the weight that that can carry, from an innocent little giggle to that which will shadow one's spirit for a lifetime. . . . They are the quiet echoes of life's delicate balance, telling of the fragility in both life and their own form; how far one can reach, which step may be too many."[14]

Should I Stay or Should I Go finds Wilson's barefoot, curly-haired girl in her iconic red dress, this time looking forlorn. She stands facing away, seeming to strike her forehead against the gallery wall in despair. The expression on her face reveals her questioning of herself, of her situation, and of the path that has brought her to this moment of indecision. Her burden of anguish, regret, and confusion is visualized in her shoulders and her arms that hang heavily at her sides. Her left foot is placed forward to indicate that she is stepping forward to the wall. She stands alone in the center of a large wooden plinth, emphasizing her smallness and her isolation. "There are times and situations that hold us frozen and locked almost unable to make the decision of whether to stay or to go."[15]

In the sculpture *On a Limb*, a bird lands on a branch just out of the little girl's reach, capturing her attention. The bird and the girl cautiously watch each other as the girl stands on her tiptoes in hopes of getting a better look. She carefully moves toward the bird. Her expression is of amazement and awe as she admires the little silver bird. The bird is Wilson's

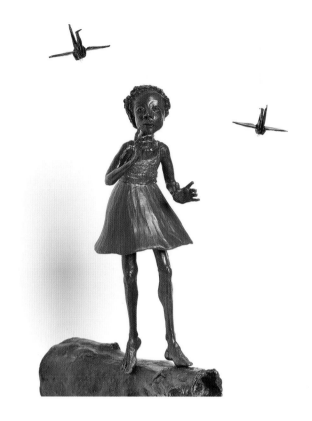

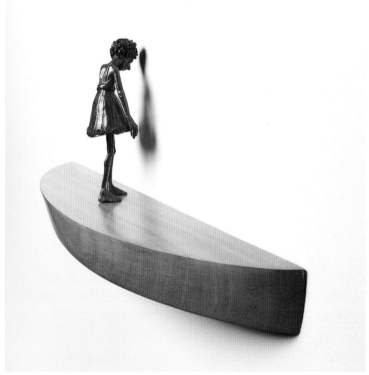

Above: *Secrets are Burdens* (detail), 2014
Bronze, flex cord

Below: *Should I Stay or Should I Go*, 2012
Bronze, African mahogany

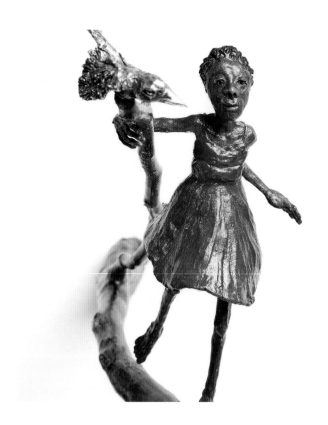

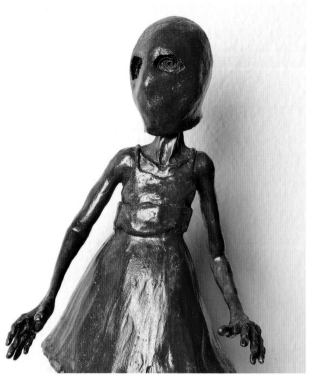

Above: *On A Limb* (detail), 2011
Bronze, sterling silver

Below: *Masked* (detail), 2012
Bronze, African mahogany

representation of the burdens of life. Wilson has a system of categorizing her birds. "I refer to [them] as 'Birdens.' While goals, objects, situations, and people may be a burden at times, they are important and precious to each of us, thus we care for them and for this reason I cast the birds in the precious metal—sterling silver."[16] She uses silver, bronze, and black patina and their associated values to reference the values of her Birdens. In *On a Limb*, the bird is made in silver, a precious metal that reflects the preciousness of the secret being shared.

Wilson uses masks in her artwork as visual devices for their transformational quality as well as for their ability to disguise. Masks possess layers of multiple meaning, from the imaginations of children to varied adult personas—identities. "As children, we make and wear masks to be anything we want . . . from being a superhero to a bird in flight. As adults . . . these masks are a way to represent [our] different personas that we need or desire to be in life."[17] Wilson uses masks to engage the viewer in the story—the transformational mask worn in *Rider* and the playful masks worn in *Belonging*. The masks in these sculptures enrich the storytelling qualities of the art. Wilson also observes the use of metaphorical masks as prompts for adult interchangeable situations. Metaphorically, adult personas become masks that are necessary to traverse the diverse identities of everyday life. Through her observations, Wilson captures people when they are vulnerable, not wearing their masks.

In *Masked*, a barefoot girl wearing Wilson's signature red dress stands atop of a pedestal. She recalls Wilson's childhood spent playing in the woods. Over her face, she wears a red stocking mask. Large eyeholes in the mask droops open to reveal her eyes. The mask covers her head and hangs loose around her neck, emphasizing the soft, knitted quality of the object. In a child's world of imagination, anything can be a mask, even an old knitted stocking cap.

Mother features a female figure sitting on a half circle of poplar wood. The use of poplar for the pedestal connects the piece to the history of Wilson's family's Delaware Tribe of Western Oklahoma and the Cherokee and

to the place where poplar grows in Oklahoma. *Mother* represents, according to Wilson, an archetype of all mothers. The mother figure is positioned on the flat side of the half circle near the far left end. The curved side of the poplar wood simulates a rocking motion and is tipped downward to accommodate the weight of the woman. Both figure and wood are balanced on an elaborately constructed steel stand. In the same way that mothers balance their lives, the figure balances on the poplar, balances on the land, balances home. In spite of her placement at the end of the half circle, the mother maintains a sense of equilibrium in her world. She is nude and exposed by her weaknesses and strengths that she cautiously balances. She sits with her legs crossed at the ankles and her arms outstretched. She is looking down at her open hands, one of which is placed lower than the other. This pose, the moving of the hands up and down, measuring against each other, mimics the motion of weighing to determine a balance within a situation, an activity that mothers are often called upon to perform. Wilson's art captures the way in which she balances her responsibilities as a mother and as an artist. "As a mother, you play a role of nurturer, educator, supporter…there's a balance of things you must take care of (that can seem like burdens) but they're still very precious."[18]

Wilson's one-of-a-kind, small bronze figurative sculptures are extensions of her cultural heritage of storytelling. Each sculpture communicates a story—a child's adventure or the recalling of memories. The facial expressions of these small bronze sculptures give voice to the figures. The tiny faces are unexpectedly detailed, delicate, and mysterious and uncannily convey the feelings of wonderment, astonishment, excitement, anticipation, and transformation. The small figures are intimate embodiments of a childlike innocence and imagination and each one characterizes Wilson's approach to her art.

Native American sculpture is a recent phenomenon within the history of American Indian art. For early artists, stone (e.g., marble, limestone.) was the medium of choice for the representation of "Indian" themed subjects that often were nostalgic and romanticized. Bronze became popular when monumental sculpture came into vogue within the Indian art market.

Opposite: *Mother*, 2011
Bronze, poplar, steel

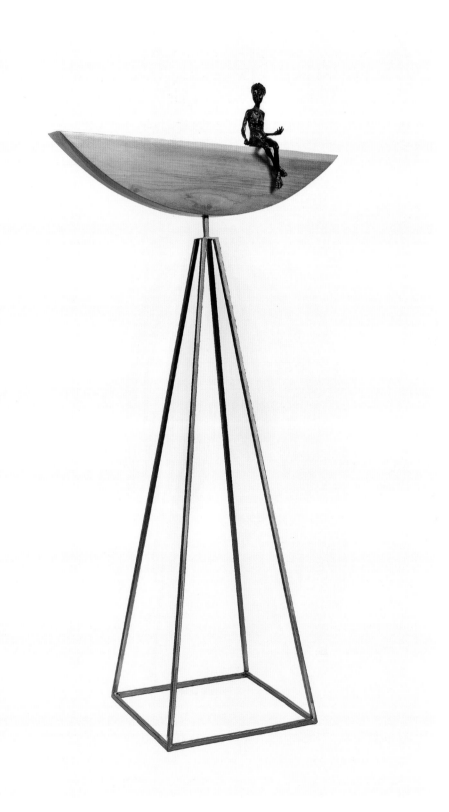

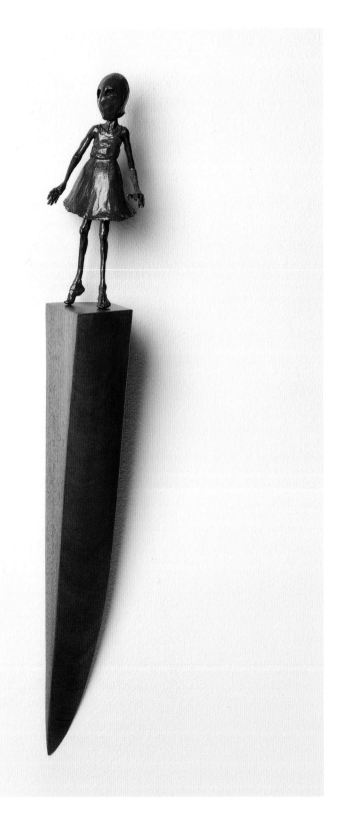

Masked, 2012
Bronze, African mahogany

The future of Native American sculpture is in the hands of artists like Holly Wilson—artists who are not bound to Indian iconography or themes to create their art. Wilson epitomizes artists who have crossed over into the world of mainstream art to define themselves, their art, and their tribal aesthetics. They are using their own experiences and defining themselves and their cultural aesthetics through their art.

[1] Holly Wilson, "Artist's Statement," on the artist's website, accessed January 22, 2015, http://www.hollywilson.com.

[2] Ibid.

[3] Thayer Tolles, Heilbrunn Timeline of Art History, American Bronze Casting, American Women Sculptors, Metropolitan Museum of Art, accessed March 26, 2015, http://www.metmuseum.org/toah/hd_abrc.htm.

[4] Holly Wilson, e-mail message to author, March 29, 2015.

[5] Jeffrey Carlson, "Holly Wilson: Behind the Mask," Fine Art Today, accessed March 30, 2015, http://www.fineartconnoisseur.com/Holly-Wilson-Behind-the-Mask/18186559.

[6] "Artist's Statement."

[7] Ibid.

[8] Ibid.

[9] Holly Wilson, e-mail message to author, April 19, 2015.

[10] Ibid.

[11] "Artist's Statement."

[12] Holly Wilson, telephone call with author, March 16, 2015.

[13] Jeffrey Carlson, "Holly Wilson's Intertwined," Fine Art Today, accessed March 30, 2015, http://www.fineartconnoisseur.com/Holly-Wilson-s-Intertwined-/20166334

[14] "Artist's Statement."

[15] Ibid.

[16] Ibid.

[17] Ibid.

[18] Ibid.

Enough (in progress), 2015
Bronze and patina
Image courtesy of the artist

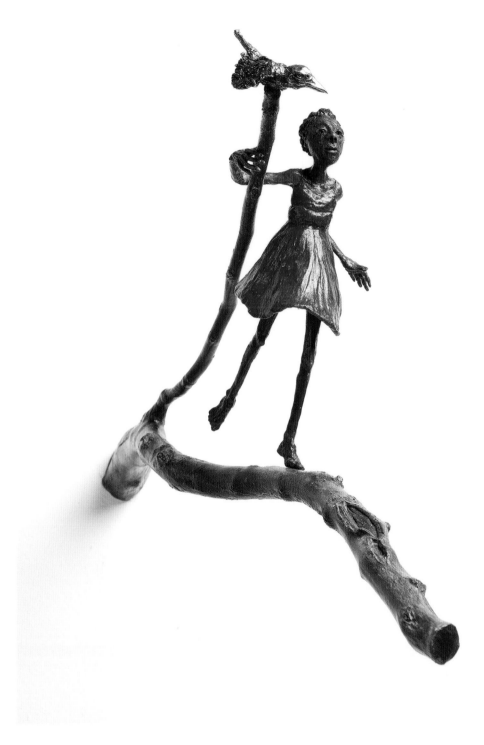

On A Limb, 2011
Bronze, sterling silver

Checklist

(Dimensions are given in inches, height by width by depth)

Mario Martinez

(Pascua Yaqui)

Ancestral Realms II, 2008
Acrylic on paper
60 x 44
Courtesy of the artist

Arizona Desert Dream (for Gorky),
2015
Acrylic, prismacolor on canvas
60 x 72
Courtesy of the artist

Blue and White, 2015
Acrylic, prismacolor on paper
60 x 44
Courtesy of the artist

Brushstroke Flower, 2015
Acrylic, prismacolor on paper
50 x 38
Courtesy of the artist

The Conversation, 2004
Acrylic, charcoal, on canvas
84 x 132
Eiteljorg Contemporary Art Fellowship
Acquisition Fund

First Captiva Dream State, 2015
Acrylic, prismacolor on paper
60 x 44
Courtesy of the artist

Floating, 2004
Acrylic, charcoal, on canvas
84 x 132
Courtesy of the artist

Inside-Outside, 2004
Acrylic, charcoal, on canvas
84 x 132
Courtesy of the artist

It's Probably Magic, 2004
Acrylic, charcoal on canvas
72 x 132
Courtesy of the artist

*Superior Mindscape (for Robert
Rauschenberg)*, 2015
Acrylic on paper
50 x 38
Courtesy of the artist

Unveiled Universe, 2005
Acrylic on paper
60 x 44
Courtesy of the artist

Luzene Hill

(Eastern Band of Cherokee)

The Pilgrimage Ribbon #1, 2005
Paper, charcoal, ink, museum board,
book cloth
132 x 11
Courtesy of the artist

The Pilgrimage Ribbon #2, 2005
Paper, charcoal, ink, museum board,
book cloth
132 x 11
Courtesy of the artist

Retracing the Trace, 2012
Cord, ink, pastel
Dimensions variable
Courtesy of the artist

Untitled, 2010
Tea, charcoal on paper
11 x 13.5
Courtesy of the artist

Untitled, 2002
Collage, charcoal on paper
9 x 11
Courtesy of the artist

Untitled, 2014
Collage, ink, pencil on paper
9 x 11
Courtesy of the artist

Untitled, 2010
Tea, charcoal on paper
13.5 x 11
Courtesy of the artist

Untitled, 2010
Tea, charcoal on paper
13.5 x 11
Courtesy of the artist

Untitled, 2013
Collage, tea, charcoal on paper
18 x 13.75
Courtesy of the artist

Untitled, 2014
Ink, charcoal on paper
14 x 11
Courtesy of the artist

Untitled, 2013
Collage, ink, tea, charcoal on paper
18 x 14.5
Courtesy of the artist

Brenda Mallory
(Cherokee Nation)

Colonization, 2003
Waxed cloth, nuts, bolts
43 x 67 x 2½
Courtesy of the artist

Interrupted Forms #2, 2014
Waxed cloth and steel
66 x 138 x 5
Courtesy of the artist

Low Tide (Dark), 2007
Waxed cloth, nuts, bolts, welded
steel
51 x 90 x 7
Courtesy of the artist

*Recurring Chapters in the Book of
Inevitable Outcomes*, 2015
Waxed cloth, hardware, nuts,
bolts, steel
Various dimensions
Courtesy of the artist

Reformed Spools, 2015
Thread on wood panel, rubber
42 x 88 x 4 (approx.)
Courtesy of the artist

Rifts #2, 2014
Collagraph print, thread,
encaustic on Rives BFK
38 x 11
Courtesy of the artist

Undulations (Red), 2012
Waxed cloth, nuts, bolts, welded
steel
48 x 80 x 7
Eiteljorg Contemporary Art
Fellowship Acquisition Fund

Da-ka-xeen Mehner

(Tlingit/Nisga'a)

Call and Respond 1 & 2, 2014
Wood, rawhide with video projection
20 x 20 x 8 (each)
Eiteljorg Contemporary Art
Fellowship Acquisition Fund

Gaaw Kootéeyaa 1, 2, 3, 2014
Wood, rawhide
20 x 20 x 8 (each)
Courtesy of the artist

Language Daggers, 2012
Steel
120 x 120 x 84 (installed)
Courtesy of the artist

Saligaaw 1-9, 2014
Wood, rawhide
20 x 20 x 8 (each)
Courtesy of the artist

Holly Wilson

(Delaware Tribe of Western
Oklahoma/Cherokee)

Belonging, 2014
Bronze and geode
9½ x 10 x 6
Eiteljorg Contemporary Art
Fellowship Acquisition Fund

Enough, 2015
Bronze and patina
10 x 16 x 10
Courtesy of the artist
(image of finished piece unavailable
for catalog)

Masked, 2012
Bronze, African mahogany
22½ x 3½ x 4
Eiteljorg Contemporary Art
Fellowship Acquisition Fund

Mother, 2011
Bronze, poplar, steel
63 x 31 x 24
Courtesy of the artist

On A Limb, 2011
Bronze, sterling silver
14 x 9½ x 19
Courtesy of the artist

The Rider, 2014
Bronze, patina and wood
21 x 63 x 5¼
Courtesy of the artist

Secrets are Burdens, 2014
Bronze, flex cord
24 x 28 x 13
Courtesy of the artist

Should I Stay or Should I Go, 2012
Bronze, African mahogany
8¾ x 22 x 4
Courtesy of the artist

Topsy-Turvy, 2015
Bronze and patina
84 x 20" x 8
Courtesy of the artist
(image unavailable for catalog)

Opposite: Brenda Mallory (Cherokee Nation)
Colonization (detail), 2003
Waxed cloth, nuts, bolts

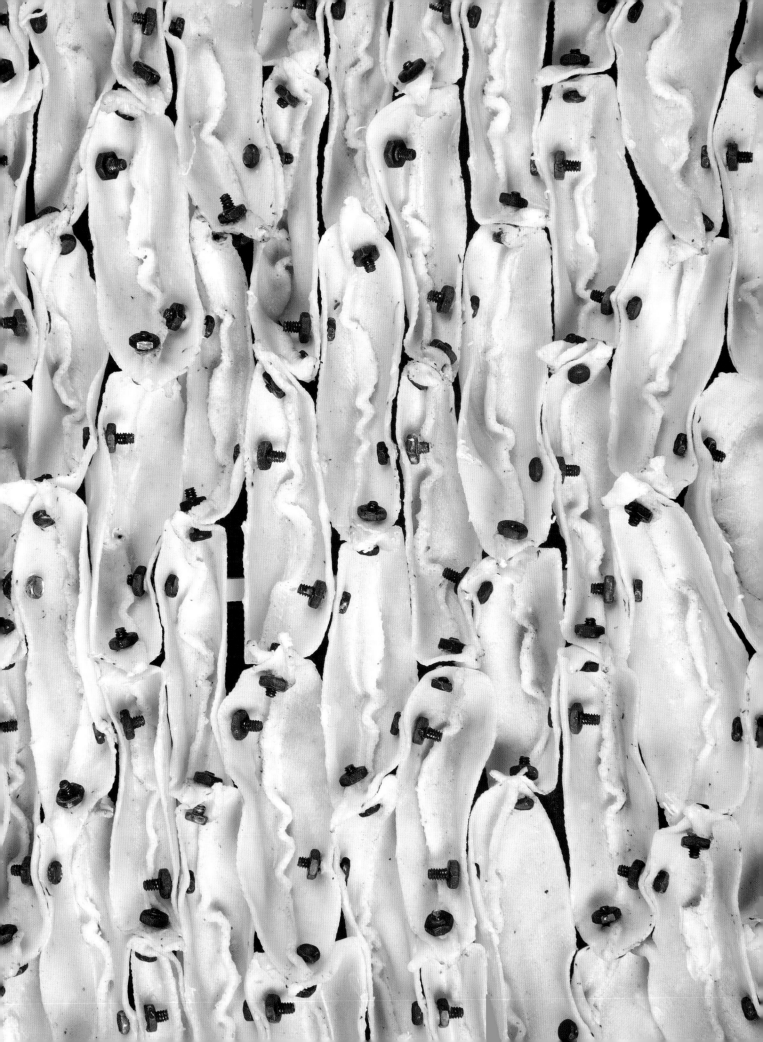

Acknowledgments

By Jennifer Complo McNutt

It takes our entire museum community to create the *Eiteljorg Contemporary Art Fellowship*. The efforts and support of our patrons, writers, editors, and staff and the appreciation of our audiences cannot be overstated. It is my pleasure to acknowledge the contributions to this the ninth round of the exhibition and project.

It is always enjoyable to work with those who provide a new interpretation of an artist's work, placing the artists in context and providing critical insight. This is an exceptional assemblage. Our appreciation to heather ahtone (Chickasaw and Choctaw Nations of Oklahoma); Margaret Archuleta (Tewa/Hispanic), Ph.D.; Martin DeWitt, professor emeritus of The School of Art and Design, Western Carolina University; and Aldona Jonaitis, director of the University of Alaska Museum of the North, Fairbanks, Alaska. We are honored to have your interpretations as part of this publication.

This is the seventh round that we have had the good fortune of working with Suzanne G. Fox and Red Bird Publishing on yet another example of her determined dedication to collecting and organizing the divergent images and essays. Thank you. In the greatest way, the beauty of this catalogue belongs first and foremost to the artists' work, which may be comprehended and absorbed most pleasurably due to the gorgeous and insightful photography of Hadley Fruits. Thank you so much, Mr. Fruits. It is our pleasure to have you on the team! And finally, Steve Sipe, director of exhibitions and design, brings the elements of the catalogue together seamlessly and with great visual sophistication, for which we are truly grateful.

The exhibition itself is a manifestation of its visionary artists. Our Eiteljorg appreciation goes to Mario Martinez (Pascua Yaqui), the 2015 Invited Artist, and the 2015 Fellows: Luzene Hill (Eastern Band of Cherokee), Brenda Mallory (Cherokee Nation), Da-ka-xeen Mehner (Tlingit/Nisga'a), and Holly Wilson (Delaware Tribe of Western Oklahoma/Cherokee).

The Eiteljorg staff has put tremendous effort and pride into this exhibition and publication. Special thanks go to the collections staff, Amy McKune, director of museum collections, and Christa Barleben, registrar, for their successful efforts toward bringing the art to the museum and overseeing its safety, no matter how complicated the task becomes. If the art is here but it is all in the vault, we depend on Steve Sipe to patiently and beautifully place it in its best light through thoughtful exhibition design. Belinda Cozzy and Ashley Robertson are relentless in the perfect arrangement and mounting of each piece, even under pressure. Thank you. When it is beautifully exhibited, great work provides a wonderful audience experience. Thanks go to our marketing professionals Tamara Winfrey Harris, Bert Beiswanger, DeShong Perry-Smitherman, and Hyacinth Rucker for getting the word out in print and in social media.

Well, who the heck pays for it all? The oftentimes unsung development crew, that is who! To Susie Maxwell, Sally Dickson, Sarah Farthing (party maker extraordinaire!), Kay Hinds, Annie Knapp, and Sheila Jackson, thanks a million!

My heartfelt gratitude goes to Ashley Holland, assistant curator of Native art, whose kind spirit and calm demeanor help guide us all. Thanks to our vice president and chief curatorial officer James H. Nottage and our president and CEO, John Vanuasdall, who continue to advocate for, promote, and celebrate contemporary Native art. There are more key staff in admissions, education, and facilities; we appreciate you! To everyone, please accept my compliments and appreciation for all your hard work.

Biographies

heather ahtone (Chickasaw and Choctaw Nations of Oklahoma) is the James T. Bialac Assistant Curator of Native American and Non-Western Art for the Fred Jones Jr. Museum of Art at the University of Oklahoma. She completed her associate's degree at the Institute of American Indian Arts in 1993 and her master's degree at the University of Oklahoma in 2006. Ahtone has worked with the Institute of American Indian Arts Museum, the Southwestern Association of Indian Arts, and Ralph Appelbaum Associates. She also curates independent exhibitions.

Ahtone began teaching at the University of Oklahoma in 2007. Her research focuses on contemporary Indigenous art. She is developing an interdisciplinary methodology analyzing the intersection between tribal cultures, traditional knowledge, and contemporaneity.

She has published articles in numerous journals, including *Indian Market Magazine*, *American Indian Horizons*, *International Journal of Arts in Society*, and *Wicazo Sa*. Her recent exhibition *Hopituy: Hopi Art from the Permanent Collections* received positive scholarly reviews and publication awards. She is preparing to mount *Enter the Matrix*, an exhibition exploring Indigenous printmakers and their work. Of Chickasaw and Choctaw descent, she also has relatives in the Kiowa community.

Margaret Archuleta (Tewa/Hispanic) is a Ph.D. candidate in art history, emphasis in twentieth and twenty-first century Native American art at the University of New Mexico. She received a bachelor of arts degree in art history and a second bachelor's degree in Native American studies with an emphasis on federal Indian law from the University of California, Berkeley. Her master of arts degree is in American Indian studies from the University of California, Los Angeles.

Prior to joining the Ph.D. program, Archuleta was the director of the Institute of American Indian Arts (IAIA) Museum, Santa Fe, New Mexico. In 2002–2003, she was the Gordon Russell Visiting Professor at Dartmouth College. She was the curator of fine art at the Heard Museum in Phoenix, Arizona, from 1987 to 2002, where she curated the landmark exhibitions

Shared Visions: Native American Painters and Sculptors in the Twentieth Century (1991) and *Remembering Our Indian School Days: The Boarding School Experience* (2000). In 1997, at the invitation of First Lady Hillary Clinton, Archuleta curated an exhibition of Native American sculpture for the Jacqueline Kennedy Garden. She has published and lectured extensively nationally and internationally on the subject of modern Native American art.

Martin DeWitt is professor emeritus in the School of Art and Design, Western Carolina University. He was founding director and curator of the Fine Art Museum/WCU for seven years and director and curator of the Tweed Museum of Art, University of Minnesota Duluth for thirteen years. He has been a curator and project collaborator for an extensive list of fine art exhibitions. His publications on twentieth-century modern and contemporary art include *Yoltéotl: Vision from the Heart-10 Latino/Chicano Artists from Minnesota; Shared Passion: The Richard and Dorothy Nelson Collection of Native American Art* and *Jovenas Cubanos NOW!* He established a contemporary Native American Art exhibition and lecture series at the Tweed Museum and at the Fine Art Museum/WCU, where he curated and co-organized numerous exhibitions, including *George Morrison, A Retrospective*; *Truman Lowe: Swirling Waters/a Tribute to George*; *Last Portraits: Fritz Scholder*; and *Luzene Hill: The Pilgrimage Ribbon*. DeWitt is himself an artist with four-decade exhibition record. His paintings, drawings, and mixed media constructions have been exhibited extensively and are included in numerous public and private collections.

Ashley Holland an enrolled member of the Cherokee Nation of Oklahoma, is the assistant curator of Native American art at the Eiteljorg Museum in Indianapolis. She received her M.A. in museum studies with a scholarly emphasis on contemporary Native art and exhibition from Indiana University-Purdue University, Indianapolis, and her B.A. in art history and religious studies from DePauw University.

Since 2007, Holland has co-curated the Eiteljorg Contemporary Art Fellowship as well as numerous exhibitions of the museum's permanent contemporary and Native art collections challenging commonly held stereotypes of Native art and culture. Holland is responsible for the development of the Eiteljorg *Celebration!* program featuring the work of

important performing Native artists and is currently developing the exhibition *Tsi Tsilagi: A am Cherokee*, which examines historical and contemporary Cherokee experiences and culture through a rich variety of artistic expression.

Aldona Jonaitis is currently director of the University of Alaska Museum of the North in Fairbanks, Alaska. In 1977, she received her Ph.D. in art history and archaeology from Columbia University. Her dissertation on Tlingit art became the basis of her first book, *Art of the Northern Tlingit* (1986). She began her career as a college professor at Stony Brook University, where she taught from 1973 through 1989. She then became vice president for public programs at the American Museum of Natural History from 1989–1993. During that period, she wrote *From the Land of the Totem Poles: The Northwest Coast Art Collection at the American Museum of Natural History* (1988), curated the exhibition *Chiefly Feasts: The Enduring Kwakiutl Potlatch*, and edited the eponymous catalogue (1991). Her more recent publications include *Art of the Northwest Coast* (2006), *The Totem Pole: An Intercultural History* (2010, with Aaron Glass) and *The Totem Pole: A Traveler's Guide* (2012). She is now collaborating with Sealaska Heritage Institute on an exhibit of Southeast Alaska Native art and a book on Tlingit art.

Jennifer Complo McNutt is the curator of contemporary art at the Eiteljorg Museum of American Indians and Western Art, where she has been instrumental in the creation and success of the Eiteljorg Contemporary Art Fellowship. McNutt has presented nearly fifty exhibitions and contributed to numerous catalogues over her twenty-five year tenure with the museum. She holds a bachelor's degree of fine art in painting and drawing from Indiana University, Bloomington, and a master's degree of fine arts in painting from Tyler School of Art, Temple University, in Philadelphia. McNutt serves the arts community nationally and regionally as a selector, contributor, presenter, and advocate for Native contemporary art. She is currently leading collaboration and contributing an essay to the upcoming Eiteljorg publication exploring Native contemporary art from 1992 to the present. In 2016, McNutt will curate a show exploring the art and personal life of Harry Fonseca through his work and correspondence, graciously donated to the museum by his partner, Harry Nungesser.

Opposite: Mario Martinez (Pascua Yaqui)
It's Probably Magic, (detail), 2004
Acrylic, charcoal on canvas

Index